AMERICA'S DOLL HOUSE

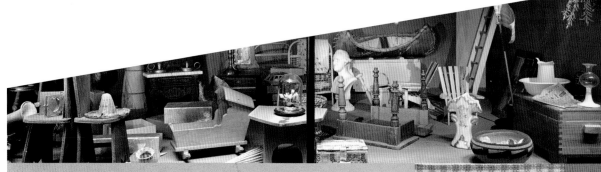

The Inhabitants

2 parents

10 children

2 grandparents

20 pets

5 household staff

given the doll house that had belonged to my old
I had never before seen a doll house so far as I
, and my delight was immediate and lasting.
was a simple little house with a flat roof and
ecoration. There were 4 square rooms, 2 on each fl
ted by plain dark wooden doors with tiny brass h
room had a window opposite the door and in each w
d pane of real glass. To the left on the ground fl
ning room, next to it the kitchen, above the dining
arlor, next to that the bedroom.
he parlor was papered in the fashion of the day w

The Parents

MR. PETER DOLL, thirty-five years old
likes: music, reading, sports

MRS. ROSE WASHINGTON DOLL,
thirty-one years old
likes: similar to those of Mr. Doll

The Pets

SPOT, hound

JOLLY, fox terrier

MR. AND MRS. WHITEY,
 rabbits

MAYDEW, springer
 spaniel

TEDDY, bulldog

SAM, wire-haired terrier

MAC, collie

NIP, cat

TUCK, cat

LADY GREY, cat

MRS. PEERIE, cat

HENRI, rat

MARCO, rat

SUN, rat

DORADO, rat

MINNIE, canary

GOLDIE, goldfish

WIGGLE, goldfish

DART, goldfish

The House

1,354 miniature specimens

23 rooms

5 stories

1 inch to 1 foot scale

4 ½ feet high

7 ½ feet wide

1 ½ feet deep

Table mat

The Children

PETER JR., eleven years old

ALICE, ten years old

ANN, seven years old

ROBIN, six years old

LUCY AND CAROL, five years old, fraternal twins

CHRISTOPHER, four years old

DAVID, eighteen months old

JIMMY AND TIMMY, three months old, identical twins

The Household Staff

ELSPETH MCNAB, nurse

GADSBY, butler

ABBY WOODTHROP GADSBY, parlormaid, commonly known as "Woodthrop"

CHRISTINA YOUNG, chambermaid

MARTHA ROOTS, cook

The Grandparents

DR. SYLVESTER DOLL, sixty-seven years old

MRS. SERENA BRADSTREET DOLL, sixty-three years old

America's Doll House

THE MINIATURE WORLD OF FAITH BRADFORD

WILLIAM L. BIRD, JR.

SMITHSONIAN INSTITUTION, NATIONAL MUSEUM OF AMERICAN HISTORY, WASHINGTON, D.C.,

IN ASSOCIATION WITH PRINCETON ARCHITECTURAL PRESS, NEW YORK

FRONTISPIECE: FAITH BRADFORD
ABOUT 1896

PUBLISHED BY
PRINCETON ARCHITECTURAL PRESS
37 EAST SEVENTH STREET
NEW YORK, NEW YORK 10003

FOR A FREE CATALOG OF BOOKS,
CALL 1-800-722-6657
VISIT OUR WEBSITE AT
WWW.PAPRESS.COM

EDITOR: CAROLYN DEUSCHLE
DESIGNER: DEB WOOD
LAYOUT: BREE ANNE APPERLEY

SPECIAL THANKS TO:
NETTIE ALJIAN, SARA BADER,
NICOLA BEDNAREK BROWER,
JANET BEHNING, BECCA CASBON,
CARINA CHA, TOM CHO,
PENNY (YUEN PIK) CHU,
RUSSELL FERNANDEZ,
PETE FITZPATRICK, JAN HAUX,
LINDA LEE, LAURIE MANFRA,
JOHN MYERS, KATHARINE MYERS,
STEVE ROYAL, DAN SIMON,
ANDREW STEPANIAN,
JENNIFER THOMPSON, AND
JOSEPH WESTON OF PRINCETON
ARCHITECTURAL PRESS
—KEVIN C. LIPPERT, PUBLISHER

LIBRARY OF CONGRESS
CATALOGING-IN-PUBLICATION
DATA
BIRD, WILLIAM L.
 AMERICA'S DOLL HOUSE : THE
MINIATURE WORLD OF FAITH
BRADFORD / WILLIAM L. BIRD, JR.
— 1ST ED.
 P. CM.
 INCLUDES BIBLIOGRAPHICAL
REFERENCES.
 ISBN 978-1-56898-974-7
1. DOLLHOUSES—UNITED STATES.
2. BRADFORD, FAITH, 1880-1970-
-ART COLLECTIONS. 3. NATIONAL
MUSEUM OF AMERICAN HISTORY
(U.S.) I. BRADFORD, FAITH, 1880-
1970. II. TITLE.
 NK4892.U6W3718 2010
 745.592'3—DC22

 2010002671

FOR *Mary*

CONTENTS

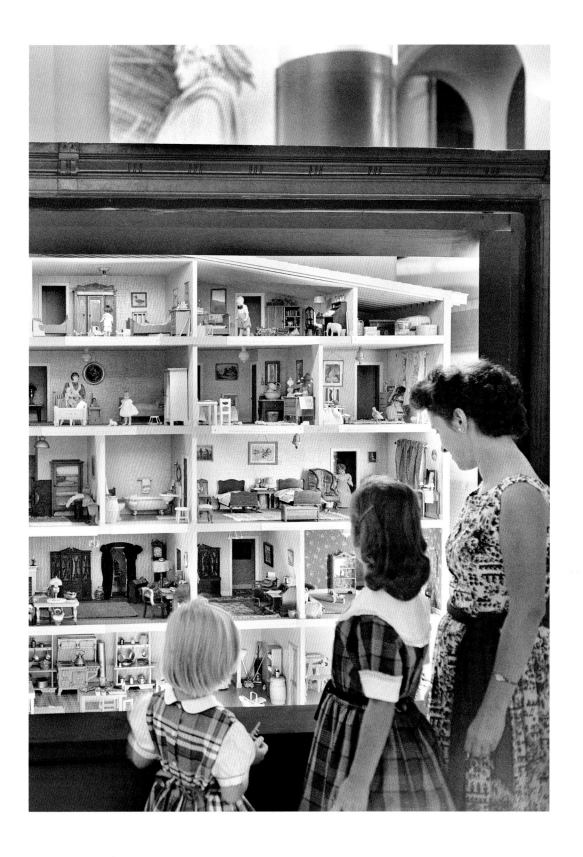

The Miniature World
of Faith Bradford:
An Illustrated History

Recently retired from the Library of Congress, Faith Bradford
needed a project. In 1949 she offered her collection of miniature
dollhouse furniture to the Smithsonian Institution's National
Museum—with a catch.

Margaret Brown visited Bradford's Chevy Chase,
Maryland, home to take a look. The sixty-nine-year-old Bradford
confided to Brown that there was no girl in her family to whom
she could leave her beloved miniatures, and the museum that she
had often visited as a child still had no dollhouse. The twenty-
six-year-old Brown, the youngest member of the museum's
curatorial staff, remembered the experience as "extraordinary."
As well she might. For Bradford practiced the immersive display
techniques of miniatures, dioramas, and period rooms that
Brown was beginning to think about for the modernization of
the museum's First Ladies exhibit. Bradford was an experienced
collector who had publicly displayed her miniatures at a charity
toy fair in 1932, and the next year, the holiday window of a
Washington, D.C., department store. She interpreted the
collection in a large dollhouse of her own design that featured the
turn-of-the-century furnishings of what she playfully described
as the Family of Doll. Though the dollhouse was no longer
presentable, its figures and furnishings were. Bradford required
a comparable dollhouse in which to interpret her collection
and Doll story. Returning to the museum and consulting her
colleagues about the donation offer that had turned into an
exhibit proposal, Brown accepted Bradford's offer with the caveat
that any future display was contingent upon finding the necessary
funds to build a new dollhouse.[1]

**National Museum visitors
with Faith Bradford's Dolls'
House, 1957**

The Dolls' House exhibited on the floor of the U.S. National Museum's Arts & Industries Building, Smithsonian Institution, 1963

The inevitable construction was a collaborative venture between the museum and its highly motivated donor. Maintaining close contact with Brown over the next two years, Bradford hired a professional model maker to build a plywood shell of floors and rooms with wallpapers and floor coverings. Receiving the semi-finished model at home, Bradford glued the furnishings and figures into place, as the museum required that everything be secured. At the museum, exhibit specialists fastened tiny mirrors, picture frames, light fixtures, and towel racks to the carefully papered walls. Brown accessioned the finished model (formally taking it into the museum's collection), and found a place for it on the floor of the Smithsonian's Arts & Industries Building (A&I).

Opened for public inspection in April 1951, the Dolls' House showcased Bradford's collection of 1,354 miniature specimens in a twenty-three-room, five-story home modeled on a scale of one inch to one foot. A label identified the setting as 1900–14, reflecting Brown's interest in furnishings and decorative arts, and Bradford's idealization of the lives of its diminutive occupants: Mr. and Mrs. Peter Doll, their ten children, two visiting grandparents, twenty pets, and a household staff of five. The Dolls' House quickly became one of the Smithsonian's most popular attractions, effectively competing for visitor attention at the A&I with the *Wright Flyer*, the Star-Spangled Banner, and the First Ladies' gowns. The Dolls' House moved from the A&I to the Museum of History and Technology, known as the MHT (now the National Museum of American History) in 1967.[2]

For the rest of her life until her death in 1970, Bradford visited the museum to give tours of her model and to answer visitors' questions. Cutting a grandmotherly figure on the floor of the museum, she wore her hair pulled up under a hat fixed with a pin. Her favorite colors were lavender and gray. Modest and self-effacing, she never sought publicity for herself or her model,

12

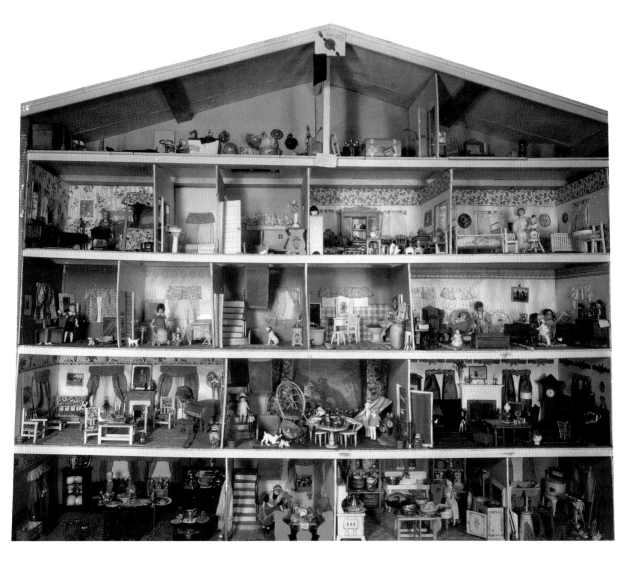

Bradford's Doll House after her first public display at Gadsby's Tavern, Alexandria, Virginia, 1932. Her blue ribbon for "best collection" and George Washington Bicentennial half-dollar prize is attached at the roof peak. Bradford had access to photographers throughout her adult life who helped document her models.

At Woodward & Lothrop's, Dec.1 - 7, 1933

Second floor
 Guest Bathroom
 For a new wall covering I used a piece of white oil-
cloth,cutting off the black and silver border to make a
plain decoration waist-high on the walls,and a decorative
border at the ceiling.
 Above the drawn shade at the window there was a white
organdy ruffle with a pale green edge.The braided rug was
green and yellow with a bleak center, and the new bath mat
was green and white. The red rubber hot water bottle hang-
ing on the left wall was probably new to this House.

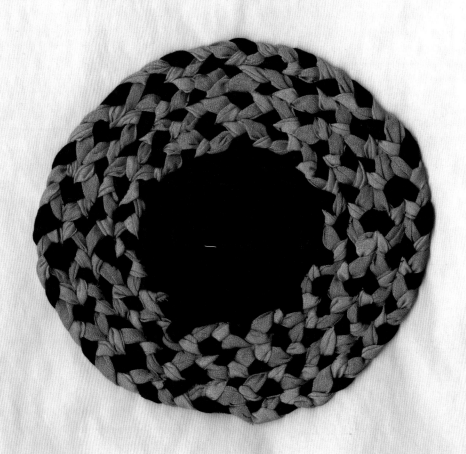

THIS IS THE ACTUAL BRAIDED RUG FROM THE ROOM

 There is no SAMPLE of the oilcloth,the ruffle above
the window,or the bath mat.

A selection of Christmas cards received by curator Margaret Brown from Bradford's Doll Family, 1951–52

Bradford's scrapbook picturing a miniature braided rug from the revised model exhibited at the Woodward & Lothrop department store, Washington, D.C., 1933. As Bradford improved her model she retired previously exhibited material to her scrapbook.

despite the fact that many regarded it as a wildly popular success. She participated in semi-annual "house cleanings," when the model's case was opened for a light dusting. The last cleaning of the year was always scheduled in December, when she brought down miniature wreaths and a tree from the Dolls' Attic to decorate for Christmas.

Bradford's dreamscape was unrestrained by the frame of display. For the first two years of the exhibit Brown received a cheery assortment of Christmas cards from Mr. and Mrs. Peter Doll and each of their children. The Dolls' Christmas cards were curiously signed and addressed in Bradford's trademark purple ink. Her finely formed hand may still be seen in the annotations that she posted to the card catalog of the Library of Congress, and to the Dolls' House typescripts that she left with the museum. All attest to her passion for thick and omniscient description. In retirement Bradford cataloged the Dolls' tastes, habits, and preferences in neatly typed household inventories, drafts of exhibit labels, a book-length manuscript, and frequent correspondence with Brown during the most intense period of the model's development between 1949 and 1951. Bradford bound her typescripts, photographs, and fabric samples in a scrapbook chronicling her development as a miniaturist—swatch by swatch, room by room, and as it turns out, house by house.

Bradford's gifts for cultural observation become clear when one considers the second model that she made for the museum between 1955 and 1959, the Modern House. Developed to accompany the Dolls' House in the MHT, the Modern House featured nineteen rooms with 785 miniatures collected specifically for the model. The total included sports cars, televisions, peg leg tables, and chairs. The model's exterior finish simulated "a slightly rough concrete." Its interior finish featured a light buff on the ground floor, ascending through lighter shades of gray on the first and second floors. The model's flat roof was painted black.[3]

15

Bradford's Modern House, 1959. Unlike the Dolls' House, the Modern House had no attic. The model featured a two-car garage, a side-porch with a roll-up bamboo blind, and a second-floor sundeck with a parapet.

Unlike the Dolls' House Attic that Bradford interpreted as a museum-like storage room, the Modern House had no such space. Bradford compensated for the sentiment-filled Attic with modern amenities, including a two-car garage with extra room for a motorcycle and a do-it-yourself workbench; a ground-floor side-porch with a roll-up bamboo blind; and a second-floor sundeck with a wrap-around parapet modeled after the rooftop terrace of the MHT. Peter Doll III and Margaret Smithson Doll—the descendants of Dolls' House patriarch Peter Doll—populated the Modern House, along with their five children, five pets, and a housekeeper.[4]

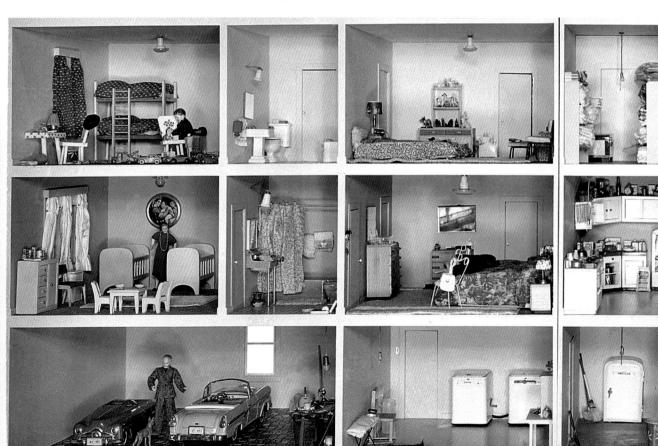

While the exhibition of the Dolls' House at the A&I brought Bradford a measure of closure with her memories of childhood visits to the "Nation's Attic" (which for all intents and purposes meant the A&I), the Modern House is best understood as her bid to participate in the modernization of exhibits for the MHT. Her decision to begin construction coincided with the 1955 announcement that the Smithsonian had won a $36 million congressional appropriation to build an edifice for the recently organized MHT. For now, the museum shared exhibit and office space at the A&I with the Air Museum, which would later become the National Air and Space Museum.[5]

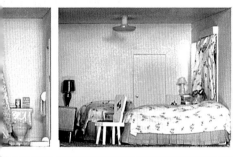

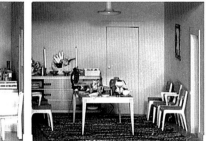
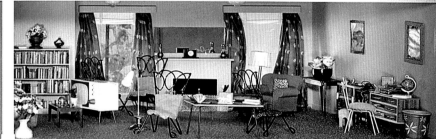
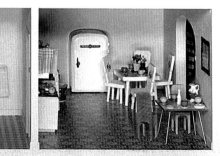
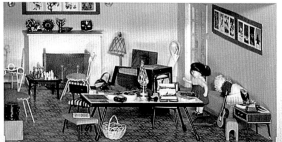

The relief of crowded display conditions at the A&I had long been the justification of the Smithsonian's building program on the National Mall. In 1955, visitors entering the building's north hall from the Mall walked beneath the *Wright Flyer* and Lindbergh's *Spirit of St. Louis*. Rows of glass and mahogany-trimmed cases that dated to the building's 1881 opening displayed artifacts relating to Washington, Jefferson, Lincoln, and Grant. The Star-Spangled Banner that inspired Francis Scott Key graced the hall's west wall. To the right of the flag, a doorway led to the First Ladies' gowns. On the east wall opposite, a doorway led to the Power Machinery Hall.[6]

Museum officials bemoaned the architectural dissonance between the Victorian building they inhabited and the story of progress culminating with the history of the United States that they wished to tell. The commodious Natural History Building opened in 1910, but until 1955 Congress routinely refused the Smithsonian's building requests. A campaign to fund a Smithsonian Gallery of Art designed by Eliel Saarinen failed to attract congressional backing in 1939. So too had officials' attempts to gain support for a Museum of Engineering and Industry in 1926, an effort that was retooled and again failed to attract congressional backing in 1946.[7]

In 1948 officials launched a program of exhibits modernization that slowly changed the interior appearance of the A&I by simply masking it off. The program, attributed to Curator of Engineering and Industries Frank A. Taylor and brought to fruition by Smithsonian Secretary Leonard Carmichael, revitalized more than appearances. By 1955 exhibits modernization helped win congressional approval for the construction of a new building for the MHT.[8]

Museum modernization did not go unnoticed by Bradford, who witnessed its success firsthand with Margaret Brown. While the first Smithsonian exhibits to be updated were in the Natural History Building, the first exhibit in the A&I

Postcard of the Mall entrance, Arts & Industries Building, 1959

North hall, Arts & Industries Building, 1948. Visitors entering the museum from the Mall walked under the *Wright Flyer* and the *Spirit of St. Louis*. A portion of the glass-enclosed Star Spangled Banner may be seen on the wall to the right.

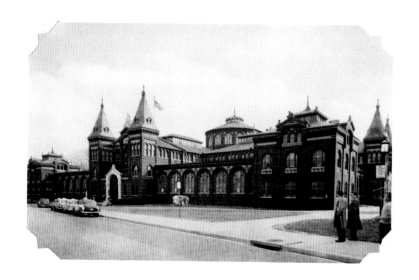

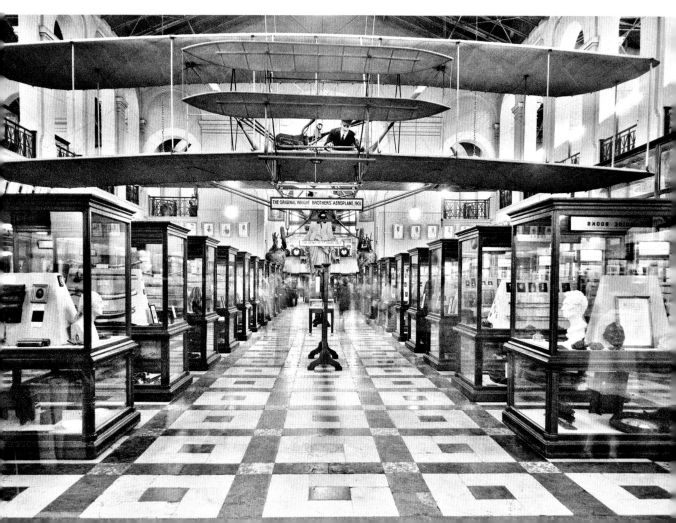

Then exhibit apprentice, Frank A. Taylor (left) helps make a phosphate mining model, Arts & Industries Building, 1923. A photo strip attached to the photograph (top) pictures the completed model.

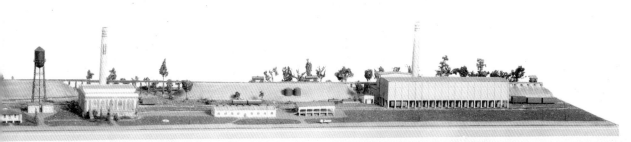

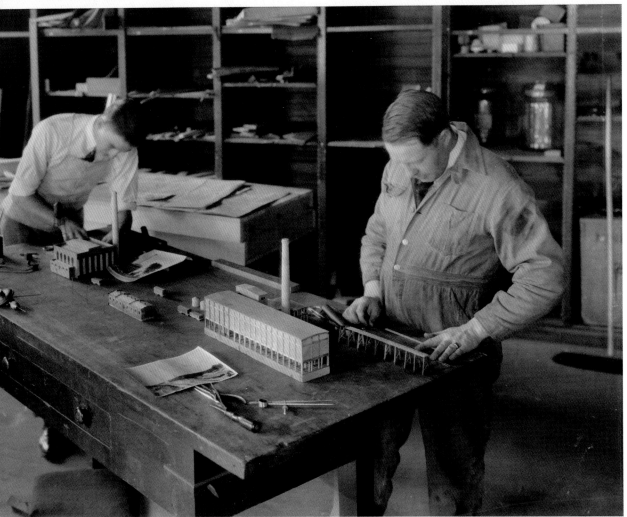

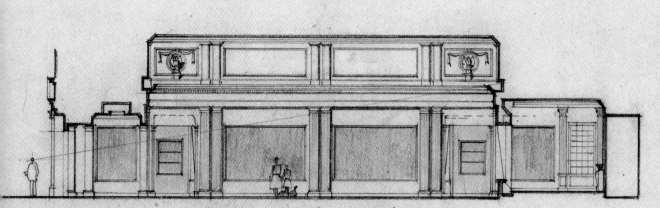

EXHIBIT ROOMS — FIRST LADIES' HALL

ARTS & INDUSTRIES BUILDING
SMITHSONIAN INSTITUTION
C.b.P. 7-2-53

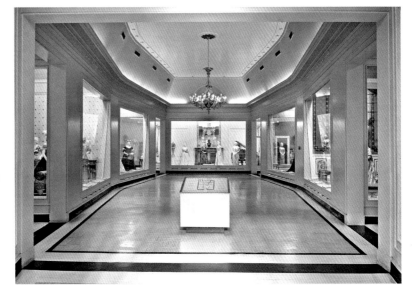

Opposite page: Architectural renderings for the First Ladies Hall, General Services Administration, 1953. The modern treatment (top) was rejected as too extreme, and the Beaux Arts treatment (bottom) was rejected as too ornate.

Top: The First Ladies Hall, 1955. A compromise was reached using modern and Beaux Arts design elements. The exhibit was the first to be modernized in the Arts & Industries Building.

that Carmichael chose to modernize was Brown's First Ladies Hall. Opened in 1954, the new First Ladies Hall exhibited its famous gowns in a series of White House–period room settings. Architectural elements gleaned from the renovation of the Truman White House enhanced the recreated room settings behind slanted window glass. The successful installation attracted the attention of officials in Washington, and the publicity from it contributed in no small way to the institution's campaign to fund the new building for the MHT.

Soon after he became the MHT's founding director in 1958, Taylor learned of Brown and Bradford's plan to create a Modern House and dismissed it much as he did the Dolls' House: first, as an unsatisfactory model of a house, and second, as a dollhouse that no child had ever played with. The fantasy that animated the Dolls' House apparently troubled Taylor as well. The whole thing seemed more at home with the curiosities of the "Nation's Attic" than the new museum that Taylor and Secretary Carmichael envisioned as an "exhibition machine."[9]

Nevertheless Bradford pressed on and completed the Modern House on schedule in 1959. As a condition of its

accession Taylor made it clear that the model was not to be exhibited. After being photographed for the record, the Modern House was crated and sent to the museum's storage facility at Suitland, Maryland. Last inventoried in its crate in 1983, the Modern House cannot be found today. The only visual record of the model comes from the black and white photographs that the museum made before consigning it to storage in 1959, and the colorful fabric cloth swatches and material samples that Bradford pasted in the scrapbook documenting the models' relationship to the museum and to her considerable reach as a miniaturist.

The dismissal of Bradford's models by some museum officials suggests how Taylor's modernization program of the 1950s rejected displays that contributed to the Smithsonian's reputation as the "Nation's Attic," an expression that came to prominence as a metaphor for the cluttered A&I.[10] While Smithsonian officials lobbied Congress to fund the institution's building program, its publicists played up the popularity of the Dolls' House and the First Ladies Hall. But as plans for the museum moved forward the highly imaginative features of Bradford's models became problematic. Despite the opportunities for display afforded by the opening of the MHT in 1964, the Dolls' House was thrust aside, the victim of a change in what the museum most valued in display. In short, its method for making itself modern.

The museum to which Bradford offered her collection in 1949 closely resembled that of her youth—characterized by halls, ranges, balconies, and connecting passageways that warehoused collections in a suspended state of exhibition. Understated budgets had long played to the advantage of museum donors who arrived with gifts and expectations of display. By the time that Bradford made hers in 1951 the pattern was well established. Perhaps the most successful example of endowment-by-display was the

 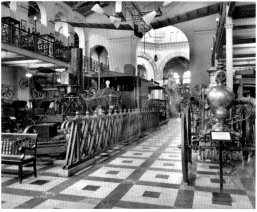

Mrs. Cassie Mason Myers Julian-James (left) and Mrs. Rose Gouverneur Hoes fit the gown of First Lady Louisa Johnson Adams on a dress form, Arts & Industries Building, 1915

The *John Bull* locomotive exhibited in the Arts & Industries Building, 1944

museum's celebrated series "Costumes of the Mistresses of the White House." Later known as the First Ladies Hall, the display of couture under glass was created and curated by volunteers Rose Gouverneur Hoes and Cassie Mason Myers Julian-James. Hoes was the great granddaughter of President James Monroe; Julian-James, a wealthy Washington dowager. Their display of gowns with period furnishings and accessories became a history lesson from Martha Washington to Helen Taft, who, with the donation of her gown, established the precedent of a sitting First Lady adding to the collection. The reasons for the display's popularity eluded many senior museum officials. For Hoes and James its emotional effect was palpable and, not coincidentally, inspired by the rainy-day discovery of a costume trunk in James's grandmother's attic.[11]

A curator with a personal stake in a collection made for passionate display. If one felt strongly about an artifact, sooner or later it would likely become the subject of a major exhibition. This was as true for dresses as it was for technological subjects derived from occupational pride. For example, J. Elfreth Watkins, formerly with the Pennsylvania Railroad and an honorary (i.e., unpaid) curator in the Department of Engineering and Industries, acquired the seminal *John Bull*, the "oldest complete locomotive in America."[12] Curators solicited collections from the leaders of industrial firms with suggestions that space could always be found for a self-interested display.[13]

Whether a dollhouse or a locomotive, an exhibit's popularity was derived from the emotion of building a collection

and making a show of it. In Bradford's case, her collaboration
with Brown was key to the Dolls' House's success. Brown and
Bradford developed an emotional bond in a museum that seldom
ventured into the world of play and fun. Yet as an exercise in
imagination, the museum's venture in dollhouse living begins
with Bradford—her childhood, her most memorable domestic
spaces, her education and training as a librarian. All point to the
release that Bradford found in collecting and craft, and what that
meant as the museum underwent a change of venue from attic to
machine.

The backstory that Bradford imagined for her Family of Doll
was as colorful as her own. She was born in 1880 in Rochester,
New York. Her parents were well-educated professional people
of middling means. Her grandfather and great-grandfather
were Congregational ministers descended from Governor
William Bradford of Plymouth Colony. Her father, James Henry
Bradford, had been a Civil War chaplain with the Connecticut
Volunteers. After the war he occupied various administrative
posts at state reform schools in Massachusetts and Connecticut.
In 1881, the year after Faith was born, he moved the family to
Washington, D.C., eventually becoming an auditor at the Bureau
of Indian Affairs. For a time he worked in an office with poet
Walt Whitman. According to family lore, Bradford shared her
father's aversion to Whitman's poetry, as it seems the unkempt
clerk aired his smelly socks on an open desk drawer. A Bradford
family history notes that James Henry Bradford had no less than
ten different addresses in Washington before he settled in Chevy
Chase with his daughter Faith in 1909. Her siblings included
Mary Knight Bradford and two older brothers, Harry Bonnell
and Horatio Knight Bradford. Horatio, whom she called Ray, was
closest to her in age by four years. Two sisters died in infancy long
before she was born.[14]

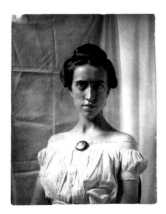

Faith Bradford photographed by her brother Harry around 1900.

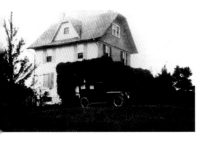

The Stone's house on Cummings Lane, Chevy Chase, Md., 1923. Bradford lived here with her sister Mary and brother-in-law George Winchester Stone until his death in 1957. Her sister died in 1946.

Her mother, Ellen Knight Bradford, was a social worker, teacher, poet, author, a songwriter of hymns, and an amateur theatrical pageant producer. Her poems appeared in *The Century* and *The Magazine of Poetry*. One memorialized the "White City" of Chicago's World's Columbian Exposition. She adapted and produced *Ben Hur* as an original tableau for her church. Demand for repeat performances followed, and she published a book to explain its stagecraft. Her production went on to be staged in more than one hundred cities across the country, typically for the benefit of local charities.[15]

Bradford grew up and flourished in the protective embrace of her family. She straddled the outer world of her mother's poetry and playacting, and the inner life of her father's charity and social work. As a child she wore her hair below her waist, a habit that she continued through her youth. Her oldest brother Harry, a student at the Corcoran School of Art, commented that she might never fear for modesty even in an artist's studio. She traveled in the social circle of her brother Ray and his friends, who shared her interests in group outings to parades, soda fountains, ice cream parlors, and visits to the Mall. She frequented the toy and specialty stores of downtown Washington where she trolled for miniatures. Family members and well-traveled friends participated in the hunt. It was not necessary to find a finished piece. Her game was to imagine one. A thimble could be a miniature wastebasket. A paper cup could be cut down and made into a decorative lampshade. The disassembled plastic housing of an electrical plug could be a ceiling light fixture. As she explained, "Everything looks like something else to me."[16]

Perhaps the one thing that she wished did not look like something else was her boyfriend. In her twenties Ray introduced her to a friend who for a time became her romantic interest. Though the depth of their relationship is not known, it ended in a disappointment. She never married. Her great nephew

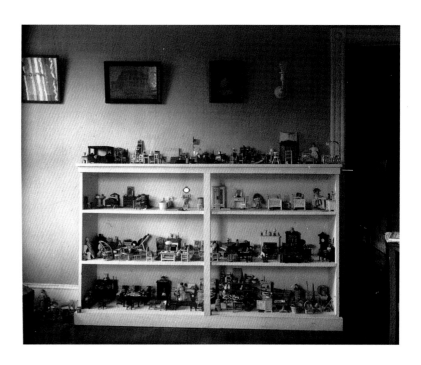

Bradford's miniature
furniture collection
displayed at home, 1930.
The collection's shelf-like
arrangement reflected the
way that she modeled her
"house" as a child.

Phillips Bradford recalled her saying when describing that part
of her life that she and her sister Mary were not very attractive;
how wonderful it was that Mary had found a husband who was so
devoted to her as his wife.[17]

Bradford graduated from Mount Vernon Seminary
(now Mount Vernon College) in 1900. She began her career as
a librarian with the Washington, D.C. Public Library in 1903,
but resigned after a few years for unspecified health reasons.
Regaining her health, she found gainful employment with the
Library of Congress Card Division in 1908. In 1942 she became
the head of the library's card catalog. When that office became
the Serial Records Division in 1944, Bradford became the first
woman to head a library division.[18]

After her father's death in 1913 Bradford lived with her
sister Mary and brother-in-law George Winchester Stone. A
graduate of the Massachusetts Institute of Technology, Stone
worked as an architectural draftsman in Boston before settling in
Washington, D.C. In 1902 he took a position in the Office of the

Supervising Architect in the Department of the Treasury, from which he retired as the assistant superintendent of architecture in 1935. Stone's private building commissions in the Washington, D.C., area included the Kenesaw apartments on 16th Street, and the Chevy Chase Presbyterian Church, a short walk from his home on Cummings Lane.[19]

In summer months Bradford took up residence at the back of her sister and brother-in-law's property in a former chicken coop. Bradford converted it to a compact bungalow that she called her "Chickalow." She surrounded her summer home with boxwoods cultivated from souvenir clippings purchased for twenty-five cents apiece from George Washington's Mount Vernon.[20]

Bradford displayed her beloved miniatures on the shelves of a bookcase. The collection's arrangement on shelves comprising the imaginary floors and rooms of a house dated to her childhood. She recalled inheriting her sister Mary's miniature furniture collection around the age of seven. The collection came with a four-room dollhouse made of light wood and pasteboard.[21]

In her scrapbook Bradford reminisced that with girl playmates, dollhouse play was predictably "domestic." Her older brothers Harry and Ray sometimes aided in "construction," but never "played the conventional doll housekeeping." Instead, they "had adventures compounded of fairy stories we had read, of Bible tales, translations of what we heard discussed by grown-ups." At one point she and Ray determined to start "the house anew" and emptied its contents onto the floor in "chaos." Designating a metal red devil paperweight as "Satan," and reverently placing a Bible on a high shelf designated as "Heaven," they stood together chanting, "Of man's first disobedience and the fruit of that forbidden tree...." They went through Milton's *Paradise Lost*, "reading the argument and carrying on ourselves from there." Bradford and her family were frequent visitors to the Arts &

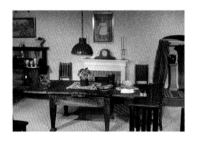

Detail of the Dolls' House Dining Room with a photographic portrait of Bradford's sister Mary above the fireplace

29

Industries Building, which had opened the year they settled in Washington. Yet even during visits to the A&I their minds turned to miniatures. "When we were not in the building examining its treasures," Bradford wrote, "we were on the grounds searching the trees for the cast-off shells of locusts which were invaluable in doll adventures, serving as chickens for food or as fierce beasts invading the house in a 'plague.'"[22]

The play settings that Bradford modeled in miniature were more theatrical than domestic, more imaginative home than house. "The family life of the dolls" included "journeys, emergencies, and festivals. They always celebrated Christmas and Thanksgiving when the dolls had a real quail cooked as a turkey." Their travels were "zestful." "The tray of a steamer trunk," for example, became "a steamer in itself with the thumb hole at the end a perfect porthole." One summer her mother moved the house outside on a porch, where the dolls rambled down the steps to work their "farm" in the family garden, while her cat took over the Dining Room for a nap, pushing the furniture to the sidewalls with the curve of its spine.[23]

When the four-room dollhouse fell apart, her under-standing mother had shelves installed in her bedroom clothes closet, and with the addition of pasteboard partitions, the shelves became the new house. Having amassed a collection of her own by this time, Bradford helped pack away her sister Mary's miniatures in two tins that had held their parents' wedding cakes. Years later they discovered that Mary's collection had been stolen. A person or persons unknown had taken the tins along with some of Bradford's miniatures. Both collections were put away during what Bradford later described as "a time of distress and sorrow in the family"—perhaps a reference to her sister and brother-in-law's children who died in infancy in 1904 and 1909.[24]

By 1932 the reputation of Bradford's miniature collection among a wide circle of friends led to an invitation to exhibit it

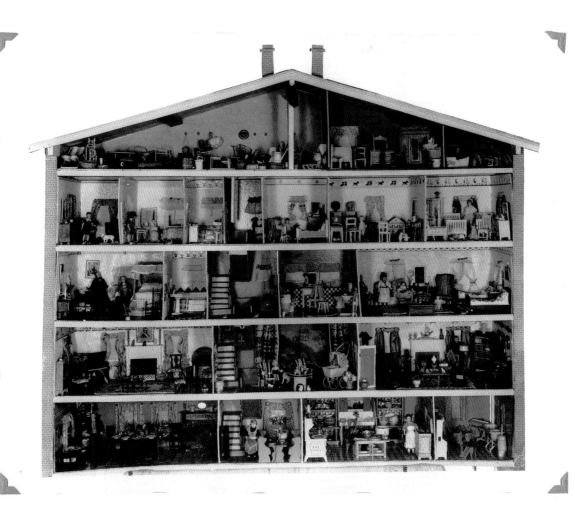

Bradford's model as exhibited in
the holiday window of Woodward
& Lothrop, Washington, D.C., 1933.
Revising the model after her showing
at Gadsby's in 1932, Bradford turned
the Living Room into a Library
and added a second chimney with
fireplaces. Her next model, the Dolls'
House, dispensed with stairs to better
show the collection.

31

at a toy fair benefitting Gadsby's Tavern in Alexandria, Virginia. The invitation happily coincided with her annual two-week vacation from the Library of Congress. With the help of her nephew George Winchester Stone Jr., her architect brother-in-law George Sr., a woodworker friend of her nephew's, and a carpenter, Bradford built a four-story dollhouse. An attic under a peaked roof distinguished the model from the bookcase in which she displayed the collection at home. The model was made the week of the toy fair. She divided each floor into three to five rooms, applying fabric window treatments and oilcloth floor coverings. She worked through the night into Saturday morning with Stone Sr., to finish. The house did not fit into the truck they had arranged, so it was tied to the top of the truck and successfully transported to Gadsby's. There Bradford set the furniture in place and sat with her work as children and adults passed by.

The public reaction to her first exhibit was immediate. Her cautions to not touch went unheeded. She looked away for a moment and saw two girls who had helped themselves to the Dining Room furniture, and "set up housekeeping" on the floor next to the house. The following day she improvised "a natural but not unfriendly barrier" with a length of clothesline strung between two chairs. Viewers completed the connection between the furnishings and the doll figures, and questioned her on apparent discrepancies. For example, why didn't she have enough beds? The answer, she patiently explained, was that two of the doll children were visiting, and did not need beds. Her logic was furnished to the last detail.

With additions and improvements, the house next appeared in the holiday window of Washington, D.C.'s Woodward & Lothrop department store the first week of December 1933. Bradford negotiated a seventy-five-dollar fee for the display with the store. Curtained off from public view for the installation, Bradford methodically set the miniatures, beginning in the

Attic and working downward until she had to lie on the floor of the window propped up on one elbow. The window unveiled, Bradford studied the reactions of passersby on the sidewalk. She noted that young children expressed little interest in the house's detail. Adults, however, spent considerable time before the glass, pointing and commenting upon the relationship of rooms, things, and dolls.[25] From 1934 to 1951 the model remained at home, though some evidence suggests that Bradford displayed it for the benefit of the local YWCA, and perhaps other charities as well. Nothing like it could be seen in the Washington area.

By the late 1940s the work of adult miniaturists had become popular features in American museums. Displays of dollhouses and detailed interior room settings came to prominence from what had been private displays that, like Bradford's, began in childhood. The intensely personal production of these displays was typical of the "saturated world" of model making and scrapbooking practiced by middle- to upper-class women who connected emotionally with the tiniest scraps and shards of their work.[26] Though Bradford never acknowledged a comparable display as the source of inspiration for her gift (except to note that many museums exhibited dollhouses), museums valued the miniature display as a medium of teaching and instruction, a popular art, a moneymaking attraction, and sometimes all three. Examples included the Stettheimer Dollhouse of the Museum of the City of New York, the Thorne Rooms of the Chicago Art Institute, and actress Colleen Moore's Doll House (also known as the Fairy Castle) of the Chicago Museum of Science and Industry (MSI). The MSI was unique among science and technology museums in justifying a fantasy display as "a stimulus for other 'castle builders.'"[27]

Within a year of her retirement in 1948, the sixty-eight-year-old Bradford began a correspondence with the Smithsonian

Curator Margaret Brown pictured with the model of the First Ladies Hall, the first Arts & Industries Building exhibit to be modernized, 1954

about her collection and her desire to exhibit it in a dollhouse worthy of the National Museum. Thus began her acquaintance with Margaret Brown (who married and became Margaret Brown Klapthor in 1955). Brown had joined the staff of the U.S. National Museum in 1943 at the age of twenty-one. A recent graduate of the University of Maryland, Brown worked in the Department of History under Captain Charles Carey, who curated military collections. Theodore A. Belote curated numismatics and presidential association objects. It struck Brown as odd that the "old men" turned over responsibility for the museum's costume collection, especially the First Ladies, to someone as young as she, notwithstanding the fact that it was women's material. The First Ladies display had gone fallow since the death of Rose Gouverneur Hoes in 1933. Brown never failed to express amazement at the circumstances of her employment and the open path the display offered. "Here is the most popular exhibit in this museum, really the prize collection, too, and it was being...You know, none of the men in the division cared about it at all. It was just being casually tossed off to a museum technician type who was coming in direct from college."[28]

As the go-to woman in the Department of History, Brown paid her first visit to Bradford's home to evaluate the collection in 1949. There and in subsequent visits Brown found Bradford's method to be completely charming. As she reported back to Carey and her superiors at the museum, "It is all completed to the smallest details and a fine representation of the style of furniture and way of life of that period."[29] If the collection were to be displayed as Bradford wished, a new house would have to be made. National Museum director A. Remington Kellogg told Brown to tell Bradford that the museum would make a provision in its 1951 budget for a model house. But if Bradford could supply a "dustproof" model with "all pieces immovable," "we will be glad to accept the house for exhibition in the National Museum."[30]

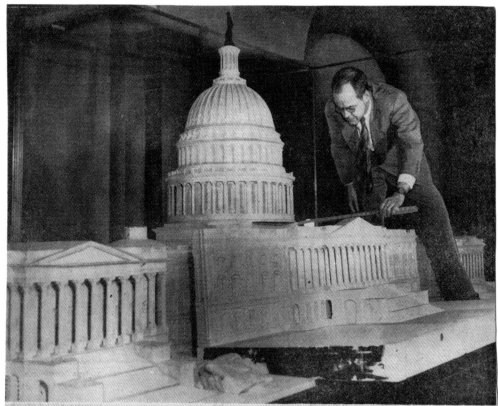

HOW CAPITOL WOULD BE COMPLETED—This model of the Capitol is being revised to show one of the plans for extension of the East front of the building. Robert Geoghegan, model builder, is measuring the model to indicate the suggested plan to project the central portion 40 feet further eastward. The proposed new portico front, identical in design to the present, has been temporarily attached to the model. Congress will be asked to appropriate $25,000 for preparation of preliminary plans and estimates of cost. The project long has been recommended to correct what has been called an "architectural defect." The base of the dome now appears to be extending over the east portico. Extension of the front of the building would provide needed additional office space. —Star Staff Photo by Ranny Routt.

Rogay's Robert Geoghegan pictured with his firm's architectural model of the East Front extension of the U. S. Capitol, 1951

Hoping that the museum would come through with the money, but willing to finance the model herself if it did not, Bradford began laying plans "for the new house for the doll family." In what she playfully called her "first annual report" to Brown, she described the proportions of each room, its contents, major pieces, and doll figures. She created back hallways running the length of the model that became the imaginary location for stairs, thus freeing more space in the rooms for the collection. Attention to even the most mundane features evinced her proficiency in managing its construction. She wrote Brown that she hoped to use "an extremely light tough wood used in

35

airplanes" to keep the model "as light as possible." She queried a friendly wood expert at the U.S. National Bureau of Standards who replied, "plywood."[31]

Bradford worked into 1950 certain that the house would be built, but not knowing who would build it, or how it would be financed. She was content to wait out the museum as long as there was work to be done. To test her domestic arrangements, she set up housekeeping with a three-sided cardboard carton the width of the largest room. She thumbtacked wallpaper samples and gathered the furnishings, "trying out a room at a time for harmony of color, correct scale, and accurate period." She apportioned touchstones among the rooms—for example, "a miniature *New York Times*, a Seth Thomas clock, a correct size coffee service, a particularly good *Webster's Dictionary*."[32]

By September 1950 Brown concluded that a contract model maker would better serve Bradford than the museum's cabinet shop. The appropriation, if successful, could be applied to either. Brown sent Bradford a list of model makers that she might contact for bids without committing to construction. Even though a decision on the museum's budget was months away, Bradford leapt at the chance.[33]

Bradford soon became acquainted with the kindred spirits of Rogay Industrial and Commercial Models. The firm's partners, Robert F. Geoghegan and Thomas J. Haynes, were well known at the Smithsonian. Their clients included the Architect of the Capitol, for whom they modeled the extension of the East Front portico in 1951.[34] On her first visit with the partners, Bradford contracted for a miniature aquarium. Geoghegan delighted her with three tiny goldfish figures suspended in clear plastic that was unique in Bradford's experience. Geoghegan visited Bradford to see the collection and discuss her requirements for the model. By March of 1950 she had the partners' bid of $625 to construct the "miniature house." The price included details such

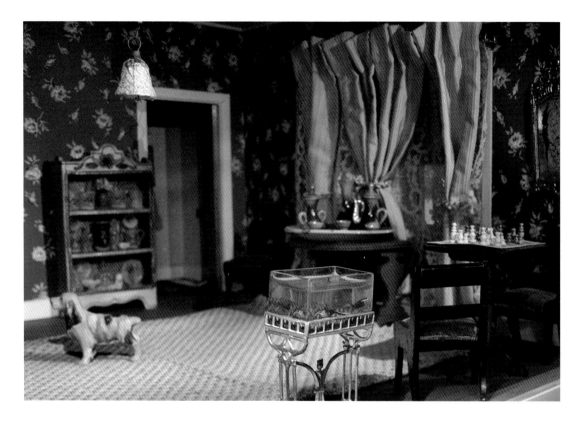

Goldfish aquarium, Dolls' House Parlor, 1951. Robert Geoghegan created a miniature goldfish aquarium and water-filled bowls for the Doll family pets. Bradford purchased many of her miniatures in Washington, D.C., area toy and specialty stores and received others as gifts.

as "baseboards, window and door frames, doors, papering and painting the interior . . . and laying of 'linoleum' where necessary." The bid specified the proper finishing of every detail, including the exterior sidewalls and roof, so that the house "could be immediately furnished and put on display."[35]

The news that the National Museum's 1951 budget did not include the money to build a dollhouse launched Bradford's last contingency. She determined that the money for the construction would be raised. Her nephew George Winchester Stone Jr. wished to give the model to her. But she would not hear of a gift. She accepted his six-hundred-dollar offer as a loan, her "mortgage." As she explained in one of her frequent letters to Brown, "I cannot allow the work and thought and time and patience and real joy and release of emotions that have gone into the years of collection to be lost."[36]

The house arrived from Rogay at Cummings Lane during the summer of 1950. She placed it in the living room and began to set the furnishings with Duco cement after the arrangements that she had practiced with the carton that had grown to cartons for each room. Bradford improvised picture frames and lighting fixtures, and received ceramic bathtubs from a potter friend. She equipped desks and washstands. She found that managing the model was more time-consuming than furnishing a full-size house. "My passion for detail is such that I shall never be *completely* satisfied with its creation, but I shall call it finished when I reach a reasonable end to said detail."[37]

When possible she documented the provenance of each specimen. "I rather like to make lists," she wrote, "and I believe I can gallop through the inventory rather swiftly (for an old lady). Then I shall write a short history of the house." Aware of the necessity of preparing a "*very* sober" account, she proposed to write the story two ways, one with Dolls (now capital D) and another without, and let Brown "select the treatment you prefer."[38] Brown deadpanned, "I expect that a judicious mixture of the two ideas would produce an account with enough dignity to satisfy the Smithsonian."[39]

Conflating the history of her collection and the story of her Dolls, the Dolls' House was perhaps the most fantastically described object ever accessioned by the National Museum.[40] Bradford made lists of miniatures that she had purchased, where and when; the items that she had received and played with as a girl that had lost their provenance; and others that she had contrived out of necessity, made by nephews, friends and acquaintances, and her weekly maid. Putting herself in the center of each room, she described its contents and features, settling on a detail here, stopping for a story there. The clarity of her room descriptions, parsed over nearly a decade from 1951 to 1959, suggests that they had been long committed to memory.

This is the home of Mr. and Mrs.Peter Doll and their family.

It is situated "somewhere" in the U.S.A., and dates from 1900 to 1914, and is on the scale of 1" to 1'.

Peter Doll was prosperous although not of great wealth, and could afford a large home with ample service for his large family.

The family consists of;

Peter and his wife, Rose (Washington) Doll

Peter Jr.,Alice,Ann,Robin,Lucy and Carol (unidentical twins)Christopher,David and identical twins, Jimmy and Timmy.

Grandfather, Dr. Sylvester Doll, and Grandmother,Serena (Bradstreet) Doll, are guests.

The nurse is a Scot, Elspeth McNab,the butler is Alexander Gadsby (know as Gadsby) the parlor maid,Mrs.Gadsby (Abby (Woodthrop) Gadsby) - know as Woodthrop, the chambermaid is Christina Young, and the cook is Martha Roots.

The rooms in the house are (reading from left to right)

Ground floor: dining room ,butler's pantry, kitchen,stores pantry,laundry.

First floor: drawing room,library,Peter's study,family parlor

Second floor: guest room,guest bath,sewing room,parents' bath, parents' bedroom

Third floor: day nursery,childrens' bath,night nursery,nurse's room,Alice's room

Top floor; attic;Robin's & Christopher's room, Peter Jr.'s room, trunk room.

Peter is in his study;Rose is in her bedroom where the baby twins are in the bassinette;Peter Jr.is in his room,Alice is in hers,Ann is in the night nursery with David and Nurse McNab; Robin is in his room;Lucy and Carol and Christopher are in the day nursery; Grandfather and Grandmother are in the guest room; Gadsby is in his pantry;Woodthrop is in the drawing room;Christina is in the childrens' bathroom;Martha is in the stores pantry Spot is in the library,Cherie is in the parlor,Teddy is in Peter Jr.'s room as are the white rats,Henri,Marco,Sun and Dorado; Jolly is in Robin's and Christopher's room*Sam is in the laundry as is Nip;Mac is in the guest room;Lady is in Alice's room, Mrs.Peerie is in the night nursery,Tuck is in the day nursery as is Minnie,the canary,

* as are Mrs.and Mrs.Whitey × Maydew

as are the goldfish, goldie, wiggle & part

neg. no 41949-B

+ Jimmy & Timmy, 3 mos.

39

The Doll biography idealized the domestic life of "an American family of the type that is passing, a large family of comfortable means but not great wealth."[41] Setting her narrative "somewhere" in the United States between 1900 and 1914, Bradford described the Dolls' tastes, habits, and interests, beginning with Peter Doll.

> The head of the family is . . . about thirty-five years old. He is successful financially, with perhaps an inheritance as a solid background. He is a man of integrity, well regarded in his community, much loved by his family. He enjoys social life, as is indicated by his gracious drawing room; is well educated, witness his well-stocked library; has an interest in music; is something of a student in his own study; and is interested in sports, by token of the trophy on his desk and his bicycle.

Bradford proceeded to "Rose (Washington) Doll,"

> Growing matronly in her repeated happy motherhood, [Rose] still retains her charm at thirty-one. She has lost none of her social ease while acquiring the skills needed to direct her large household. She and Mr. Doll have many interests in common—in social life, in cultural attainments, and the sincere practice of their religion.[42]

Carefully calibrating the biology of Mrs. Doll's "repeated happy motherhood," Bradford noted that the Dolls' ten children included two sets of twins.

She named the butler "Gadsby" after the tavern, and the parlor maid "Woodthrop" after the department store. The only figure named for an actual person was "Martha Roots," in honor of the cook "who served in my family for many years." Racial

composition went unacknowledged, although ethnicity was. The children's night nurse, Elspeth McNab, for example, was of "good Scots parentage."[43]

The logic of the model began with the service area of the Laundry, Pantry, and Kitchen leading into the Dining Room on the ground floor, progressing to the first-floor Drawing Room, Library, Study, and Parlor. The second floor exhibited guest and adult bedrooms and baths, and a Sewing Room. The third and fourth floors were the domain of children, featuring bedrooms, a Night Nursery, and a Day Nursery outfitted with a dollhouse. In the museum-like Attic Bradford placed the rough-hewn miniatures that she had played with as a girl, including a folding steamer chair, a spinning wheel, an oak table displayed with its legs in the air, a white chest, and an iron pot and skillet given to her by an aunt who had played with them as a girl, Bradford noted, circa 1838.

The first installation of the Dolls' House in the A&I Building in 1951 allowed for a close inspection of the rooms, but not for a complete inspection by children and short adults. Within a month of the model's debut, Brown wrote to Bradford to tell her of several alternatives under consideration to make the model more accessible. These included building a special case with recessed fluorescent lighting, the addition of a step in front of the case, and a reduction of the model itself.[44]

Bradford replied that she was "shocked at the proposal" to "cut into the House," and "very troubled" by the museum's willingness to even suggest such an "unfortunate rearrangement." She was "completely dismayed." "I denied myself many things to make the house complete and I went deeply in debt to be able to provide a house worthy of the museum," she wrote. She respectfully settled for Brown's "first idea," "that the House be put in a deeper case and rimmed with fluorescent light, and a bench (or step)... provided for the use of children and short adults."[45]

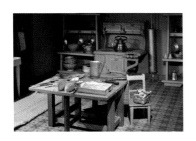

Detail of the Dolls' House Kitchen table

41

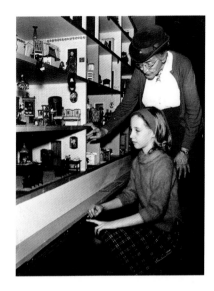

Faith Bradford gives a Dolls' House tour to a young museum visitor, 1966. A favorite on the museum floor, Bradford decorated for Christmas with a miniature tree and wreaths stored in the model's Attic.

Laundry room, with partial view of Peter's bike through the doorway to the back hall, the Dolls' House, 1951

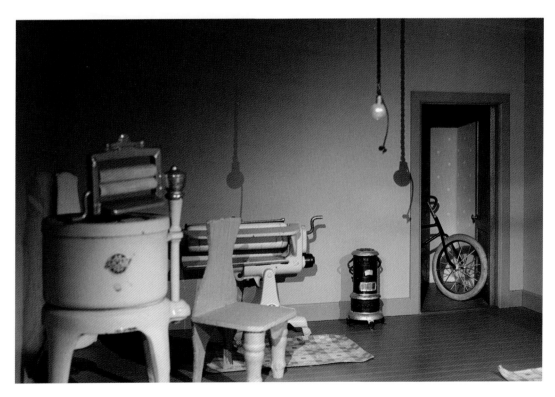

Made more accessible to visitors, the model weathered the changes unscathed.

Bradford visited the museum for semi-annual "house cleanings," using the winter visit to decorate the house for Christmas. A miniature toy train layout and tiny presents, hidden in a back hallway, joined the tree in the Parlor on the second floor. She thumbtacked wreaths between the floors. History and fantasy blended in her frequent tours, impossible to compartmentalize. Describing the back hallway that contributed to the model's illusion of depth, she could not help but note that Peter parked his bike there, visible through the Laundry room door. Or that the goldfish suspended in Rogay's plastic water were named "Goldie, Wiggle, and Dart, and no one can tell them apart."[46] She left her visitors on the threshold of the Attic, a place of memorable associations "filled with many things," "too recently used to be easily discarded," pausing long enough to note an ornamental statue of an "iron deer," "taken from the lawn in the interest of modernization."[47]

The press described the Dolls' House as one of the Smithsonian's most studied and enjoyed attractions. *Washington Post* reporter Flora Gill, a Chevy Chase neighbor and fellow miniature collector, suggested that the national housing shortage established the cultural context for the Dolls' House's reception as a fantasy. Gill noted that museum visitors of a certain age identified with the furnishings represented by the model, while its detailed room and Attic settings held young visitors in rapt attention.[48] Bradford's example inspired a Brownie Scout troop to create a dollhouse for Washington's Children's Hospital. The Brownies made their house from orange crates papered with wallpaper samples. The furniture was spools and cardboard boxes. Learning of their inspired construction, Bradford contributed a ceramic bathtub, curtains, two bathroom hampers, and figures of a rat and a cat.[49]

43

Praise for the Dolls' House was long and sustained, all
the more so for Bradford's presence on the floor of the museum.
In 1958 Emily May Ross, a museum technician in the Division
of Civil History, published an account of Bradford's tour in
the *Christian Science Monitor*. Ross observed that visitors regarded
the detail of the rooms and furnishings as an affirmation of the
past, busy with Victorian color, texture, and detail. The Kitchen
icebox had tiny bottles of milk. A smoked ham hung on the wall.
A blue cookie jar had come from Japan in the last shipment
received before Pearl Harbor; a silver canister on a shelf was a
tiny souvenir of the 1893 World's Columbian Exposition. The
Library displayed actual books, including Washington's Farewell
Address. In the Pantry, the light bulb dangling from the ceiling
above Gadsby's head was a pearl, the tiny pull chain cut from a
gold necklace. On the Attic level, the Trunk Room awaited future
trips and adventures. Bradford concluded the tour leaving visitors
to contemplate the Attic. This time she stopped to note a bust
of George Washington with a chipped nose. Like the museum,
the Dolls' House was publicly available and all for free. Ross's
headline proclaimed, "Every American Owns This House."[50]

The spirited expression of public ownership was then very much
on the mind of Secretary Leonard Carmichael, who became the
Smithsonian Institution's seventh secretary in 1952. The former
president of Tufts University, Carmichael was a behavioral
psychologist, educator, and administrator. Carmichael brought
his psychological tool kit to bear upon the management of the
Institution's campaign to realize its museum building plans.
In doing so, Carmichael taught the Institution to talk not
just to Congress, but to everyone. Carmichael described the
Smithsonian's one-hundred-million-dollar building proposal
in *Coronet* magazine, a popular weekly within easy reach of
the nation's supermarket checkout lanes. In between articles

44

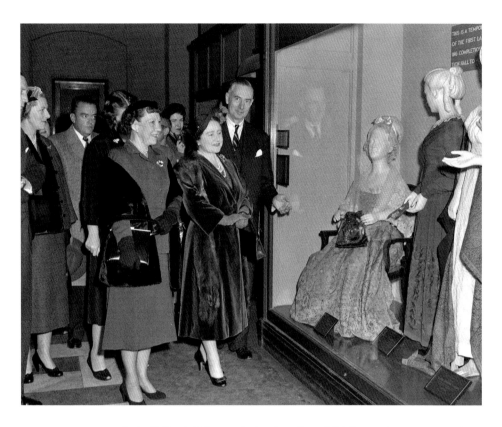

From right to left, Carmichael, the Queen Mother, Eisenhower, and Brown (partially obscured) tour the First Ladies collection during the latter stages of the new exhibit's construction, 1954. FBI Director J. Edgar Hoover leads the tour's security detail.

entitled, "Who's Who in Whistling" and "I Swam for 21 Hours" appeared Carmichael's urgent appeal, "NEEDED: A New National Museum." Beginning with the tattered condition of the Star-Spangled Banner, Carmichael linked the storied past of the Smithsonian Institution with the story of progress. "The Institution was world-renowned when the electric light and the gasoline engine came into being," Carmichael explained. "The U.S. has moved on to its great power and authority in the machine age, and now, in the atomic age. Yet, the Smithsonian remains, physically, in the era of the buggy whip." Carmichael concluded, "Our most urgent need is for a real Museum of History and Technology to take the place of the crowded, dimly lit old building next to the castle."[51]

Carmichael's decision to put the First Ladies at the top of the A&I's modernization list became a similar case in point. Carmichael grasped the potential of a modern exhibit to

45

win the imagination of the public, and thereby the Congress, for new museum facilities. Helping Carmichael in the stage-management of official expectations was Margaret Brown, who had developed a close working relationship with First Lady Mamie Dowd Eisenhower. In May 1955 Mrs. Eisenhower visited the A&I to check on the progress of the new hall with England's Queen Mother in tow. Their visit was recorded for the cameras with a beaming Carmichael who accompanied Brown, the First Lady, and the Queen Mother on a tour of the exhibit in the latter stages of construction.[52] The Smithsonian's one-hundred-million-dollar building program proposal was then at a critical juncture in the Congress before the House Public Works Committee. A similar bill had been introduced in the Senate.[53]

Bradford closely followed Carmichael's public relations campaign with Brown as the proposal moved through Congress. Museum publicists delighted in the human interest features that Bradford inspired, contributing to the campaign for the new museum into which the Dolls' House presumably would be put. Though Bradford knew little of television, and refused to have one in her room at home, in April 1955 she consented to be interviewed by Arlene Francis, host of NBC television's *Home* show. The hour-long network telecast was staged live on the floor of the A&I, and featured a tour of the new First Ladies Hall with Brown, and a tour of the Dolls' House with Bradford. At the conclusion of their tour, Francis presented Bradford with a letter from the network "to retire your mortgage and to make your house free and clear of all debts and encumbrances." Earlier Francis had found out about the loan, the balance of which was in the neighborhood of fifty dollars. Francis's on-air revelation that NBC would be making the final payment on her "mortgage" came as a complete surprise. When the telecast was over, Brown noticed that Bradford seemed out-of-sorts. What was wrong? Clutching NBC's mortgage-ending note, she replied, "I wanted

to pay it myself." Otherwise the telecast was a complete triumph. As Brown wrote to her superiors, "Again it resulted in a great deal of favorable publicity which advanced our efforts for a new building."[54]

It is interesting to speculate about the likely sources of Bradford's modernism. Within a month of the opening of the Dolls' House Bradford wrote, "I think that Peter Jr. will marry early and I expect will be involved in World War II. If he has a son Peter III, in uniform or out of it, I am sure said Peter III will be looking for a 'ranch type' house for himself, his wife and a child or so."[55] It would be a modern house, she later explained. "Modern but not extreme."[56] Bradford's ideas were not far removed from Carmichael, Taylor, and the lingering classicism of the architectural renderings of the new MHT. Bradford's brother-in-law George Winchester Stone, with whom she lived until his death in 1957, had retired as the federal government's assistant supervising architect in 1935. Stone oversaw the end of the era of monumental office building projects typified by the Federal Triangle across Constitution Avenue from the site of the new museum. There were of course contemporary museum exhibits to consider as well. The American Institute of Architects, to whom Bradford donated her Chickalow boxwoods in 1957, celebrated its centennial that year at the National Gallery of Art. The first photography exhibit ever mounted by the Gallery pictured examples of the residential architecture of Greenbelt, Maryland, and the Hollin Hills development of Fairfax, Virginia.[57] Well-publicized examples of residential architecture by Frank Lloyd Wright, Charles M. Goodman, J. P. Trouchoud, and Walter Gropius existed within a mile or two of Bradford's Chevy Chase, Maryland home.[58]

Flush with success from the opening of the First Ladies Hall in 1955, Brown was in a position to insist that, this time, the museum pay Rogay to fabricate a model for Bradford, as

47

Bradford and NBC had famously paid for the first. The date of
the purchase order indicates that Brown prepared it in 1956, but
held off until the architectural design of the MHT was determined
in 1958. Bradford took her cue from the rendering of the new
museum. The museum's white marble-clad exterior was echoed
in Bradford's simulated slab-sided concrete construction. Her
model's roof was flat, and its topmost floor had a sundeck with
a parapet like the museum's rooftop terrace. Brown submitted
the purchase order with Bradford's drawings to Taylor, who had
just become the MHT's founding director. Taylor, who quietly
harbored doubts about the Dolls' House and did not know
about Brown's interest in building another, refused the
request.[59]

Taylor's refusal exposed the fault line between the
museum's social-cultural and scientific-technological divisions.
Noting that he could not approve Brown's request on the basis
of the "justification given," Taylor queried Department of Civil
History chair Anthony Garvan, "What real purpose will the
modern house serve? What plans do we have for the present
home?"[60] Garvan replied, "I am sorry that I did not more heavily
endorse the enclosed memorandum. It was because I felt that,
apart from the price [$745], approval would have been virtually
automatic." "The present house," explained Garvan, "if not the
most popular exhibit in the A&I Building, is certainly one of the
most popular three or four exhibits." Though Garvan did not
elaborate, a short list of the most popular exhibits at the time
included the First Ladies Hall, the Star-Spangled Banner, the
Wright Flyer, and the *Spirit of St. Louis*.[61]

Taylor's response to Garvan spoke volumes about the
assumptions of the competing interests within the MHT that
looked past each other in puzzling out a place for Bradford's
models in the museum. Taylor explained his objections as a
matter of model making.

48

> The existing dollhouse is a popular exhibit because it is
> a doll house and a good one. It is not, in my opinion, a
> good representation of a home. I do not believe that the
> new one would be a good representation of a home. . . .
> This comes to a question of whether we want to exhibit
> two doll houses as doll houses, now. *My recommendation is
> that we do not.* . . . If in MHT we decide to show interiors
> with miniatures, let us obtain good ones. If we wish to
> collect dollhouses, let us collect those that children have
> played with.[62]

The job of conveying Taylor's refusal to Bradford fell to Brown,
who had encouraged Bradford to continue the success of her
Dolls' House with a modern equivalent, and who might be
forgiven for feeling that Taylor had pulled the rug out from under
both of them. More disturbing was Taylor's challenge, in the
form of a question, about the legitimacy of the Dolls' House, and
its future as an exhibition. Noting Taylor's interest in collecting
dollhouses "that children have played with," Brown conceded,

> The existing dollhouse did begin as a four room doll
> house, but the house we have now was never played
> with as a doll house. Miss Bradford collected for the
> house for fifty years, and her idea was that it was to be a
> representation of an early twentieth-century home. I felt
> her success was measured by the fascination her house
> has for young and old. As a matter of fact, the errors of
> scale and the personal taste represented by it are a part of
> its charm.[63]

Brown noted that Bradford planned to continue with the modern
project, regardless. Brown wrote Garvan that Bradford "told
me that she intends to go ahead and have the work done herself,

'though it will beggar me' because she is most anxious to have the companion house here at the Smithsonian before she dies."[64]

Piling on in Bradford's defense, curator Wilcomb Washburn weighed in on the practical, aesthetic, educational, and filiopietistic reasons to continue to exhibit the Dolls' House—and to collect another. First, he believed, Carmichael may have talked with Bradford about it, and may have encouraged her to that end. Moreover, "Miss Bradford's conception of the house, whatever its distortion of literal reality, is a legitimate artistic conception of reality." This was the first time that a museum official had spoken about her work in this way. Her interpretation, Washburn wrote, was as valid as that of the artist El Greco whose imaginative work interpreted Christ's Apostles. "Miss Bradford's version of a modern house will, I am sure, be marked by emotional insight and philosophic humor." Referring to the modern seating lines of Charles Eames and Eero Saarinen, Washburn noted, "I am eagerly anticipating her choice of an object to represent 'those chairs that look like potato chips.'" The final reason for giving the modern house a chance, Washburn quipped, was "She's my cousin." The two shared a common ancestor in Governor William Bradford.[65]

Faced with the united front of the museum's Department of Civil History, Taylor conceded, but not entirely. The museum would fund the construction of the Modern House, and Bradford would "set" the model at her leisure. But when finished, the model was to be photographed, crated, and sent to the Institution's storage facility at Suitland, Maryland. The MHT would not exhibit the Modern House.[66]

Bradford appears to have taken the news in stride. She would not have to take on the responsibility of another "mortgage." The Modern House would be made. Every provision was taken so that she might finish her work. The model was hinged so that it could be broken into two sections for easier handling, a feature that allowed her to set the furnishings at her I Street

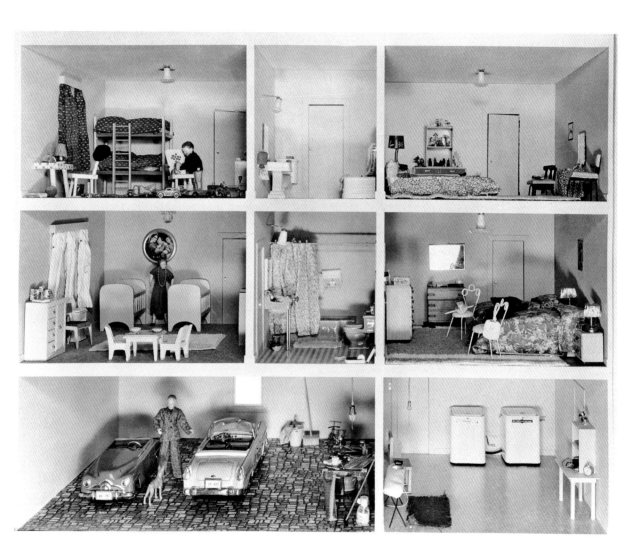

Detail left section, the Modern House, Bradford scrapbook, 1959. From left to right, ground floor: Garage, Laundry; first floor: Nursery, Parents' Bathroom, Parents' Bedroom; second floor: Peter III's Room, Children's Bathroom, Linda Lu's Room.

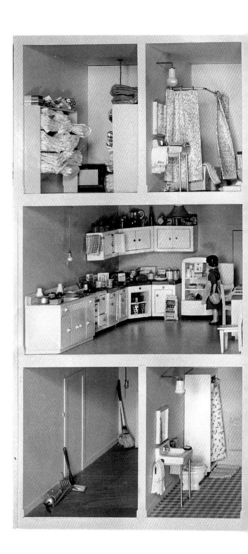

Detail right section, the
Modern House, Bradford
scrapbook, 1959. From left
to right, ground floor: Utility
Room, Lavatory, Recreation
Room in two sections
divided by an archway,
Patio; first floor: Kitchen,
Dining Room, Living Room;
second floor: Linen Room,
Guest Bathroom, Guest
Bedroom, and Sundeck.

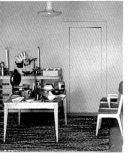
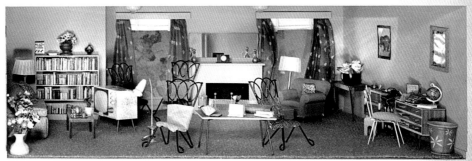
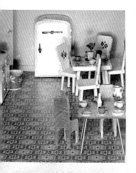
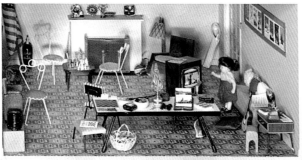

apartment. Knowing that the model would be put away, she held it back so that her visitors could take in its comment and detail. Peter III's garage workbench, for example, was "covered with a disarray of tools, some blueprints, and a book, *Do It Yourself*." On his boxer dog, "Tweezer," she placed a solid gold collar, "a ring cut from my finger" that had become too tight. In the Laundry room, she dryly noted, "stands the washing machine and its twin dryer, the latter a washing machine converted by a change of name to a dryer." Features of the ground floor rec room included young Linda Lu Doll contemplating a television with a tipped-in picture of Arlene Francis. A nearby table featured "a book of Washington views opened to show the Smithsonian Institution" and another entitled, *It's Later Than You Think*.

Brown and Washburn paid their respects to the model at I Street, and found the Modern House to be everything that they hoped it would be. Washburn attempted one last time to raise Taylor's interest in displaying it beside the Dolls' House, but Taylor refused the bait. "I prefer not to," Taylor replied. "Once we try it we are committed and I can see no point in getting in deeper on this."[67]

Museum modernization, challenged by a Modern House, raised questions about what was desirable in a modern museum. Bradford's models spoke to the emotional qualities of display. In the eyes of the museum's technological enthusiasts, her models were relics of the museum's attic-like past. Hers suffered from errors of scale, a realm in which sentiment counted for little. As Brown, Washburn, and Garvan suggested, sentiment was the point. Sentiment was why her models worked.

The Museum of History and Technology opened in January 1964 with acres of exhibit space, more than four times the square footage of the A&I Building. The realization of the new museum was Taylor and Carmichael's lasting achievement, and deservedly

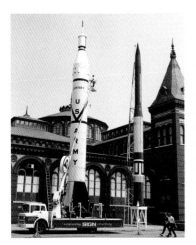

The beginning of "Rocket Row," Arts & Industries Building, 1965

so. For all of their success in winning the appropriation from Congress for the construction, Taylor and Carmichael's bid was helped by the public's love for the attractions of the attic. The Star-Spangled Banner occupied a place of honor at the center of the new museum, the point at which the building's architectural design deposited visitors, some by escalator, to begin their tour. The *John Bull* occupied a place of honor in Garvan's new exhibit, "The Growth of the United States." The First Ladies Hall became bigger and more majestic. The Dolls' House, however, was not moved to the MHT. For the time being it remained behind at the A&I. A punishment? A penalty? Neither, really. It was simply not part of Taylor's plan. In fact, Taylor asked Brown what *her* plan for it was.[68]

By 1965 the removal of collections to the MHT all but emptied the A&I. The MHT's last remaining display, the Dolls' House, was moved to the north hall, leaving the south, east, and west halls to the Air Museum. In response to Taylor's query, Brown proposed that the Dolls' House be exhibited with a display of nineteenth-century toys. Rodris Roth, a recent Winterthur graduate and curator in the Department of Civil History, made the selection and wrote the script.[69] But in exile the Dolls' House remained much as it had been—a floating object, a stand-alone attraction, a house without a home.

Until her death in 1970, Bradford continued to hope for the display of the Modern House. Anticipating that day, she continued to collect miniatures, leaving instructions for their placement in the model. These included a red plastic motorcycle for the garage, new figures of Peter and Margaret Smithson Doll, and small household appliances and accessories.

Apparently Bradford never complained to Taylor or Carmichael about the storage of her model or the consignment of the Dolls' House to the A&I when it had been given over to what Taylor described as "temporary exhibits of NASA and

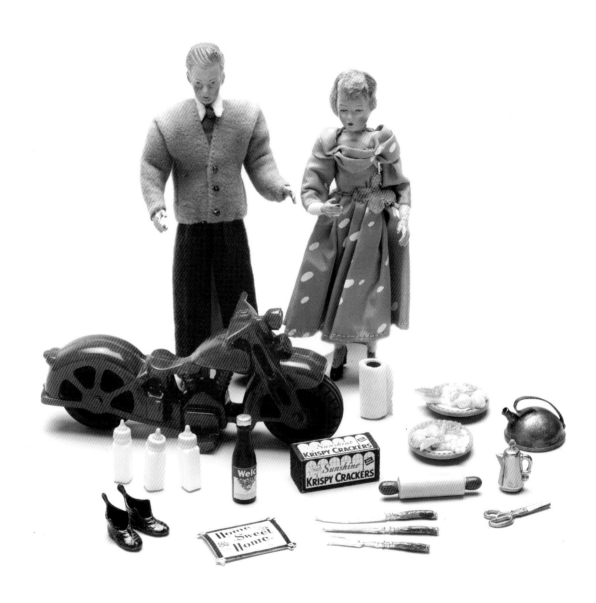

To go on stove in kitchen of Peter
Doll Jr's house, in place of kettle
now there.
If there is no kettle on stove of
recreation room (1st section)
place kettle withdrawn from
kitchen, there.
 Faith Bradford

Miniatures collected for the Modern House after 1959. Bradford continued to collect miniatures for her model and left instructions for their placement. The total included a red plastic motorcycle, shoes, baby bottles, a sampler, grape juice bottle, cracker box, carving set, paper towels, rolling pin, fruit plates, scissors, coffee pot, tea kettle, and replacement figures of Peter III and Margaret Smithson Doll.

other agencies" staged by the Air Museum.[70] Bradford did visit
with Taylor in 1962. Whatever they talked about can only be
surmised from Taylor's polite thank-you note for recounting
"the fascinating details of the history and significance of Peter's
house." "Your fine presentation of the meaning of each room and
its furnishings was most enjoyable," Taylor wrote. "I am now much
better prepared to show the house to my visitors and to explain
how much thought, care, and searching went into the organization
of the furnishing of this most popular exhibit."[71]

In the space of a decade, the "Nation's Attic" had become
an "exhibition machine." The former had its uses. Coming into
popular parlance in the late 1940s, the expression "Nation's Attic"
became a metaphor for the cluttered conditions that Smithsonian
officials hoped to remedy with a modern building program. The
"Nation's Attic" metaphor was laden with sentiment that officials
believed worked at cross purposes with "modernization." Despite
officials' success in financing the construction of a building, as
a metaphor the "exhibition machine" never resonated beyond
the job site. Smithsonian publicist Paul Oesher complained that
"the 'Nation's attic' approach to the Smithsonian is getting a little
tiresome—especially when 'dusty' is added." Oesher wrote that
"some of the new halls are really fine—the best of their kind in the
world. But I suppose 'Nation's attic' will persist ad nauseam."[72]

The Modern House might have helped ease visitors from
the attic into the machine that critics dismissed as "Government
Modern," "a sometimes brave, sometimes timorous attempt to
climb onto the contemporary bandwagon."[73] When the MHT
opened to the public in January 1964, reviewers noted that the
building itself was "an exhibit of modern technology." The exhibit
featured escalators, elevators, solar glass to protect exhibited
objects, built-in cables for television cameras, a television studio,
metal grid ceilings, drop-in panels for changing exhibits, visitor
lounges, a sheltered drive for school buses, and a cafeteria.[74]

Left: Mall entrance showing the relationship of the Washington Monument to the Museum of History & Technology, 1964

Right: Parking entrance to the Museum of History & Technology, 1964

Indulging the machine metaphor, critic Ada Louise Huxtable explained, "The museum is a machine to exhibit in, to paraphrase Le Corbusier's famous dictum that a house is a machine to live in . . . it is a museum-factory to be divided at will." Outside, Huxtable continued, "the factory is disguised as a monument."[75] Other critics were unforgiving of the museum's interior marble walls, terrazzo floors, stainless steel, and chrome. The treatment took efficiency too seriously, like a store, an office lobby, or a reception area "in a prosperous soft-drink bottling plant."[76]

Within months of the MHT's opening the unexpected happened. The arrival of modernism on the Mall evoked nostalgia for the A&I. As one critic put it, "Gone is the charm of rummaging through the murky, crowded old museum, and of discovering some inventive contraption tucked away in a cranny." "A trip through the old building always brought back memories of the secret expeditions up to grandmother's attic, or discovering a long-forgotten toy bank, perhaps, or a Victorian bustle."[77] The metaphor of the museum and the home was easily drawn.

Taylor was beloved as the founding director and visionary of the MHT. Still, history and technology remained administrative factions under the guise of a single museum. Noting the ascendance of the museum's technological specialists,

as late as 1979 one critic complained that the Smithsonian
had long "laid low," ignoring its "Victorian buildings" and
"pretending its collection of women's dresses (gowns of the wives
of American presidents) was not at the heart of its operation."[78]

The same might have been said for Bradford's model.
The date when the Dolls' House first appeared on the floor of the
MHT cannot be determined precisely, or what finally precipitated
its dispatch from the A&I.[79] Months after the MHT opened,
Brown realized that the best that could be made of the situation
was to publish the Dolls' House history that Bradford had written
in 1951. This was not the "judicious mixture" of historical and
fantasy accounts that might satisfy the dignity of the Smithsonian.
This was Bradford's fantasy account of the Family of Doll.[80]

Brown contributed an introduction describing the
physical model and the collection of miniature furnishings that it
displayed. Brown noted the many "contrived" pieces that Bradford
had created out of necessity. These included the Sewing Room
ceiling light made from an oilcan, lampshades from cut-down
paper cups, and linoleum from oilcloth. Wilcomb Washburn
described the significance of Bradford's model in light of the
changes taking place around it in the museum. He wrote,

> The Bradford Doll house is an interpretation of the past,
> and one must accept it as an interpretation. Its limitations
> are those of the artist, whose eye sees some things as
> important and some as unimportant, who works with
> toy furniture that may or may not fit into a prearranged
> scale, who expresses mood and color and emotion rather
> than precise scale and measurement. Just as the artist
> communicates through a medium that may be distorted
> technically, so does Miss Bradford convey the life of the
> early 1900s through her interpretation of the household
> center. In that period the household was a real center;

and the house was not a roosting place only, for the times
in between trips to the supermarket, the movie house, or
the beach. It was not a "machine for living."[81]

As she edited the manuscript for publication, Brown asked
Bradford to list the small changes that she had made to the model
over the years during her many "house cleanings." Working from
a photograph, the eighty-four-year-old Bradford recalled that
she had placed an art glass pitcher on the Dining Room table. She
had installed a picture of her helpful nephew on a fourth-floor
sidewall. In the Attic she had removed an off-scale pot and pan,
and replaced them with a tidy pile of Christmas wreaths. When
both of the models had been briefly available to her in 1959, she
substituted a cocker spaniel for a poodle in the Dolls' House,
giving the poodle to the Modern House. She did not elaborate.[82]

Bradford lived with the models and the museum for which
they were made. In the end the comment that she most cared
to make was material. One of the last changes she noted was the
addition of a miniature lamp with a missing globe that she had
placed on top of a cedar chest in the Attic. The lamp had been
her sister Mary's, the only surviving piece "from the original
four-room doll house that started the collection."[83] Spared while
awaiting repair, it had not been packed in the cake tins stolen
years before. Cementing that lamp in the Attic spoke volumes
about how deeply Bradford carried the loss of her sister and the
absence of a girl to inherit her life's work. It was a reply, if it could
be called that, to the museum officials who complained that her
models were less than they might have been for never having been
played with by a child.

The Dolls' House created its own following among visitors
who shared Bradford's sentimental attachment to miniatures.
With the opening of the Museum of History and Technology,
officials positioned their exhibition program as a metaphorical

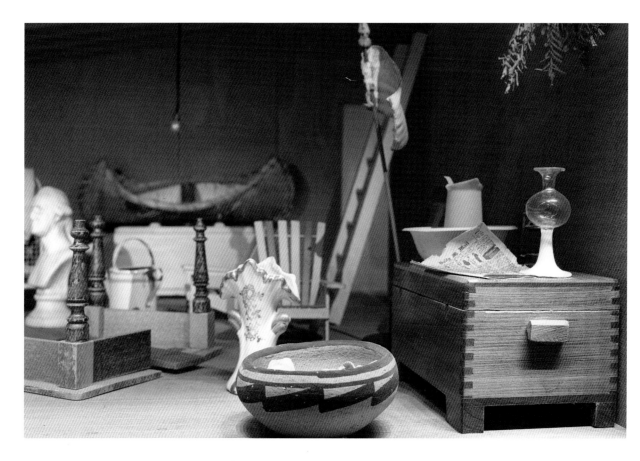

The miniature lamp with a missing globe that Bradford glued to the top of the cedar chest in the Attic, the Dolls' House, after 1951. The lamp was the only surviving miniature of her sister's collection that ignited Bradford's craft.

machine, not an attic. In its new surroundings the Dolls' House created expectations among children and adults that officials could only ignore at their peril. The standoff revealed the shortcomings of museum modernization that seldom ventured into the world of play and fun, where Bradford lived out her life imagining and dreaming.

1 Margaret Brown to Faith
Bradford, May 24, 1949; Bradford,
"Peter Dolls' House," TS, Object
Documentation file, accession
190558, Division of Political
History, National Museum of
American History, hereafter NMAH;
Ink Mendelsohn, "Dolls' Houses
Hold Riches in Miniature," Los Angeles
Times, December 15, 1983.

2 Bradford accession file
190558, April 13, 1951, Office of the
Registrar, NMAII.

3 Wilcomb Washburn to
Anthony Garvan, May 7, 1958,
Bradford accession file 225696,
NMAH.

4 Bradford accession file
225696, June 11, 1959, NMAH.

5 Officials expected to open
the new museum in 1960. Steven
Lubar and Kathleen M. Kendrick,
Legacies: Collecting America's History at
the Smithsonian (Washington, D.C.:
Smithsonian Institution Press,
2002); Cynthia R. Field, Sabina
Wiedenhoeft, and Robert J. Orr,
The Beginnings of the Modern Museum:
National Museum of American History:
Architectural History and Historic Preservation
(Washington, D.C.: Smithsonian
Institution Press, 1999); Robert J.
Orr, The Making of a Modern Museum:
Report on the Design and Construction of
the National Museum of American History,
Behring Center, second edition
(Washington, D.C.: Smithsonian
Institution Press, 2004).

6 Ellis Yochelson, National
Museum of Natural History: 75 Years in the
Natural History Building (Washington,
D.C.: Smithsonian Institution Press,
1985); Nicholas Clark, "Charles
Lang Freer: An American Aesthete
in the Gilded Era," American Art
Journal 11 (October 1979): 54–68;
Cynthia R. Field, Richard E. Stamm,
and Heather P. Ewing, The Castle: An
Illustrated History of the Smithsonian Building
(Washington, D.C.: Smithsonian
Institution Press, 1993).

7 "3 Michigan Architects
Win On Smithsonian Gallery
Design," Washington Post, June 29,
1939, 3; "Model of Gallery Put on
Display," Washington Post, June 28,
1953, L3; Leslie Judd Portner,
"Need for A New Gallery Here,"
Washington Post, July 12, 1953, L3;
Arthur P. Molella, "The Museum
that Might Have Been: The
Smithsonian's National Museum of
Engineering and Industry," Technology
and Culture 32 (1991): 237–63; Marie
Plassart, "Narrating 'America': the
Birth of the Museum of History and
Technology in Washington, D.C.,
1945–1967," European Journal of American
Studies 1 (2007), http://ejas.revues
.org/document1184.html; Pamela
M. Henson, "'Objects of Curious
Research': The History of Science
and Technology at the Smithsonian,"
in "Catching Up with the Vision:
Essays on the Occasion of the 75th
Anniversary of the History of Science
Society," supplement, Isis 90 (1999):
S249-S269; Marilyn Sara Cohen,

"American Civilization in Three Dimensions: The Evolution of the Museum of History and Technology at the Smithsonian Institution" (PhD diss., George Washington University, 1988).

8 Plassart, "Narrating 'America'"; Henson, "'Objects of Curious Research.'"

9 Carmichael described the new museum as a "great exhibition machine." See "Fourth Oral History Interview with Frank A. Taylor," March 20, 1974, Smithsonian Institution Archives, RU 9512, Box 1; Taylor, "The Museum of History and Technology: The Smithsonian's Newest," *Museum News,* n.d., History Files, Division of Political History, NMAH.

10 "The Nation's Attic," *New York Times Magazine,* August 4, 1946, 101.

11 Rose Gouverneur Hoes (compiler), *Catalogue of American Historical Costumes, Including Those of the Mistresses of the White House As Shown in the United States National Museum* (Washington, D.C.: Waverly Press, 1915); Margaret W. Brown, *The Dresses of the First Ladies of the White House (As Exhibited in the United States National Museum),* (Washington, D.C.: Smithsonian Institution, 1952); Benjamin Hufbauer, *Presidential Temples: How Memorials and Libraries Shape Public Memory* (Lawrence, Kans.: University Press of Kansas, 2005), 109–106 and *passim.*

12 Lubar and Kendrick, *Legacies,* 137–41; John H. White Jr., *The John Bull: 150 Years a Locomotive* (Washington, D.C.: Smithsonian Institution Press, 1981), 39.

13 Eric Nystrom, "'Your Name Would Be Conspicuously Present': Curators, Companies, and the Contents of Exhibits at the Smithsonian, 1910–1925," paper, Annual Meeting of the Organization of American Historians, Washington, D.C., April 19–22, 2006.

14 Faith Bradford, *Bradford Genealogy* [n.d.]; Bradford Stone, *A Line of Bradfords 1460–1988* [n.d.]. Further biographical details are drawn from the reminiscence of her great nephew George Winchester Stone Jr. in "Faith Bradford, 1880–1970: Librarian and Creator of the Dolls House Now at the Smithsonian," TS, received March 29, 1980, Object Documentation file, accession 190558, Division of Political History, NMAH.

15 Ellen Knight Bradford, *National Cyclopedia of American Biography,* vol. 2 (New York: James T. White and Company, 1895), 174; Bradford, *Selections from "Ben Hur" Adapted for Readings with Tableaux* (Washington, D.C.: Ellen Knight Bradford, 1887); Bradford, "Visible Sound," "Farewell, White City," and "The First Electric Message," *The Magazine of Poetry,* February 1895, 101–2.

16 Phillips V. Bradford to author, February 5, 2010; "Little Girl's Hobby Grows Into Popular MHT Exhibit," *The Smithsonian Torch,* July 1968, 3.

17 Bradford to author, February 5, 2010.

18 Stone Jr., "Faith Bradford." Bradford published a memoir of Elizabeth J. Somers, the founder of Mount Vernon Seminary. See also Faith Bradford, *Elizabeth J. Somers* (Norwood, Mass.: Plimpton Press, 1937).

19 James Goode, *Best Addresses: A Century of Washington's Most Distinguished Apartment Houses* (Washington, D.C.: Smithsonian Books, 1988), 55–8.

20 Stone Jr., "Faith Bradford."

21 Bradford wrote and rewrote her reminiscence many times. I have drawn the following account from her scrapbook, 1959, accession 225696, Division of Political History, NMAH.

22 Ibid.

23 Ibid.

24 Ibid. A son, Stephen Winchester Stone, b. July 10, 1904, d. August 2, 1904; and a daughter, Katherine Abigail Stone, b. February 14, 1909, d. July 1, 1909 from cerebral meningitis. See http://www.concentric.net/~pvb/GEN/mkbrad.html.

25 Bradford Scrapbook, 25.

26 Beverly Gordon, *The Saturated World: Aesthetic Meaning, Intimate Objects, Women's Lives, 1890–1940*

(Knoxville, Tenn.: University of Tennessee Press, 2006). See also the example of Frances Glessner Lee whose fascination with police work inspired her to model miniature crime scenes that she then used to train detectives in criminal observation in Corinne May Botz, *The Nutshell Studies of Unexplained Death* (New York: Monacelli Press, 2004).

27 Sheila W. Clark, ed., *The Stettheimer Dollhouse* (San Francisco: Pomegranate, 2009); Art Institute of Chicago, *Miniature Rooms: The Thorne Rooms at the Art Institute of Chicago* (New York: Abbeville Press, 1983), 11–5; *Miniature Rooms by Mrs. James Ward Thorne* (Phoenix, Ariz.: Phoenix Art Museum, 1963); *Colleen Moore's Doll House* (Chicago: Museum of Science and Industry, 1949); Scott H. Rose and Terry Ann Neff, *Inside the Fairy Castle* (Chicago: Bulfinch Press, 1998).

28 Margaret Brown Klapthor, "Oral History Project Session with Margaret Brown Klapthor, Curator, Division of Political History, Department of Social and Cultural History, Association of Curators Project," February 17, 1983, #9522, SIA, 39–40.

29 Brown to Carey, March 22, 1949, accession file 190558, NMAH.

30 Brown to Carey, April 5, 1949, accession file 190558, NMAH.

31 Bradford to Brown, May 16, 1949; Bradford to Brown, September 12, 1949, accession file 190558, NMAH.

32 Bradford to Brown, September 12, 1949; Mendelsohn, "Dolls' Houses Hold Riches in Miniature."

33 Brown to Bradford, September 22, 1949, accession file 190558, NMAH.

34 "'Model' Business Develops from Model Building Hobby," *Washington Post*, November 12, 1948, C8; "How Capitol Would Be Completed," *Washington Star*, n.d., Bradford Scrapbook.

35 Rogay Industrial & Commercial Models to Bradford, March 14, 1950, accession file 190558, NMAH.

36 Bradford to Brown, March 19, 1950, accession file 190558, NMAH; "Little Girl's Hobby Grows Into Popular MHT Exhibit," *The Smithsonian Torch*, July 1968, 3.

37 Bradford to Brown, July 24, 1950 and October 5, 1950, accession file 190558, NMAH.

38 Bradford to Brown, October 5, 1950, accession file 190558, NMAH.

39 Brown to Bradford, October 11, 1950, accession file 190558, NMAH.

40 The donation was recorded as a "Miniature House—the miniaturized furnishings of a typical American home of the period 1900– 14, 21 furnished rooms, an attic and a trunk room; and a typewritten manuscript story of the house." Accession file 190558, April 13, 1951, NMAH.

41 Flora Gill Jacobs, *A History of Dolls' Houses* (New York: Charles Scribner's Sons, 1953), 236–7.

42 Faith Bradford, *The Dolls' House* (Washington, D.C.: Smithsonian Publication 4641, 1965).

43 Ibid.

44 Bradford to Brown, May 9, 1951, accession file 190558, NMAH.

45 Ibid.

46 Bradford, "The Story of the Miniature House (Early Twentieth Century)" TS, n.d., Object Documentation file, accession 190558, Division of Political History, NMAH.

47 Ibid.

48 Flora Gill, "Here's A Nifty Housing Solution!" *Washington Post*, November 18, 1951, S3. Gill began collecting miniatures in 1945, published extensively on the history of the subject, and in 1975 founded the Washington Dolls' House and Toy Museum. The museum closed in 2004. She described Bradford's "life-long creation" as "one of the best-known dolls' houses in the United States." Flora Gill Jacobs, *A History of Dolls' Houses* (New York: Charles Scribner's Sons, 1953), v, 236–7; Obituary of Flora Gill

Jacobs, *New York Times*, June 12, 2006.
49 "The Inspection...the
Result," *Washington Post*, December 30,
1951, S5.
50 Emily May Ross, "Every
American Owns This House,"
Christian Science Monitor, November 15,
1958, 23.
51 Leonard Carmichael,
"Needed: A New National Museum,"
Coronet 38 (May 1955): 53–6.
52 Eileen Summers and
Ruth Shumaker, "Queen Mother,
Mamie Tour Town," *Washington
Post*, November 6, 1954, 23; Edith
Evans Asbury, "Royal Guest Sees
First Ladies Garb," *New York Times*,
November 6, 1954, 19. Mamie
Eisenhower returned with the
President for the formal opening
of the exhibit, where she threw a
ceremonial switch illuminating
the first modern exhibit at the
A&I. "First Ladies on View at
Smithsonian," *Washington Post*, May 25,
1955, 1; Ruth Shumaker, "History's
'Fashion Parade' Is Reviewed by
Eisenhowers," *Washington Post*, May 25,
1955, 32.
53 Jeanne Rogers, "New
Museum Indorsed [sic] for
Smithsonian," *Washington Post*, April
30, 1955, 1; "$36 Million Museum is
Voted by Committee," *Washington Post*,
May 21, 1955, 17.
54 John G. Fuller to
Bradford, April 26, 1955, regarding
a W-4 form for a check to retire her
mortgage, Bradford Scrapbook. The

telecast is mentioned in "Annual
Report FY 1955," Department of
History, Division of Civil History,
folder 13, box 88, RU 158, SIA.
Special thanks to Marcel C.
LaFollette who called my attention to
a shooting script for the telecast with
an attached note from Smithsonian
publicist Paul H. Oesher, April 22,
1955, Webster Prentiss True papers,
box 1, folder: television, accession
T91027, SIA.
55 Bradford to Brown, May
1, 1951, NMAH; Flora Gill, "Here's
A Nifty Housing Solution!"
56 Bradford, "Peter
Dolls' House" TS, n.d., Object
Documentation file, accession
190558, Division of Political
History, NMAH.
57 Frederick Albert
Gutheim, *One Hundred Years of
Architecture in America, 1857–1957,
Celebrating the Centennial of the American
Institute of Architects* (New York:
Reinhold, 1957). Bradford donated
her boxwoods to the AIA's Octagon
House. George Winchester Stone
Jr., "Fields, Fruits, and Flowers,"
TS, January 14, 1990, Chevy Chase
Historical Society, Chevy Chase, Md.
58 For anecdotal examples of
how modernism became a middle-
to upper-class phenomenon in
residential Washington, D.C., see
Anita Holmes, "Modern Makes the
Grade in Tour-Conscious D.C.,"
April 13, 1952, *Washington Post*, S13;
"Second Annual Modern Home

Tour Today," *Washington Post*, April
20, 1952, R13.
59 Purchase order #40047,
September 5, 1956 and attached
memo, Klapthor to Taylor, "Request
for construction of a contemporary
Doll House to be furnished by
collection of Miss Faith Bradford,"
April 3, 1958, accession file 225696,
NMAH.
60 Pencil annotation, Taylor
to Garvan, on Klapthor to Taylor,
April 3, 1958, accession file 225696,
NMAH.
61 Mary Van Renssaelaer
Thayer, "Inside the Nation's Attic
Are 35,000 Rare Items," *Washington
Post*, February 27, 1955, F1.
62 Taylor to Garvan, April
25, 1958, accession file 225696,
NMAH.
63 Klapthor to Garvan, May
6, 1958, accession file 225696,
NMAH.
64 Ibid.
65 Washburn to Garvan,
May 7, 1958, accession file 225696,
NMAH.
66 Taylor agreed that
the museum would pay for
the construction of the model
"providing it is made so that it
can be disassembled for storage."
Klapthor to Wilding, July 3, 1958,
accession file 225696, NMAH; the
museum's annual report described
the accession as "the furnishings of
a modern home," saying nothing
about the model that the museum

had contracted for, and in which the furnishings were attached. "Miniature furnishings of an American doll house, period 1945– 55," accession file 225696, *The United States National Museum Annual Report for the Year Ended June 30, 1960* (Washington, D.C.: Smithsonian Institution, 1960), 114.

67 Washburn, through Garvan, to Taylor, March 5, 1959, with Garvan's note and a note from Taylor, March 10, 1959, accession file 225696, NMAH.

68 Taylor to Klapthor, through Howland and Washburn, March 29, 1965, regarding Doll House in the A&I Building, Division of Political History, 1961–1964, box 89, Departmental files, 1954–1975, Director, National Museum of History and Technology records 1944–1975, RU 276, SIA.

69 Rodris Roth to Klapthor, May 19, 1965, regarding the north hall, Exhibit files, Division of Political History, NMAH. A similar or perhaps second installation of the show opened in the MHT's third-floor special exhibit gallery in 1966. Rodris Roth, "Playthings Old & New Special Exhibit," TS, March 1, 1966, exhibit files, Division of Home & Community Life, NMAH.

70 Taylor to Klapthor, March 29, 1965.

71 Taylor to Bradford, May 22, 1962, folder: Division of Political History, 1961–1964, box

89, Departmental files, 1954–1975, Director, National Museum of History and Technology records 1944–1975, RU 276, SIA.

72 Paul Oesher, "Post Mortem," *Washington Post*, February 17, 1957, H2.

73 Ada Louise Huxtable, "New (Architectural) Frontier in Washington," *New York Times*, August 19, 1963, 72.

74 "Service for Visitors Ranks with Exhibits," *Washington Post*, January 23, 1964, A18.

75 Ada Louise Huxtable, "Architecture: Blending the Classical and the Modern," *New York Times*, January 23, 1964, 28.

76 Wolf Von Eckardt, "Architects Goofed on Interior of Museum," *Washington Post*, January 26, 1964, G6.

77 John W. Finney, "'The Attic' Moves," *New York Times*, April 19, 1964, XXI.

78 Henry Mitchell, "Victorian Amusements and the Bustle in the Skies," *Washington Post*, June 22, 1979, E1–4.

79 The Dolls' House was first noted in an MHT visitor guide in 1967.

80 Faith Bradford, *The Dolls' House* (Washington, D.C.: Smithsonian Institution, 1965).

81 Wilcomb E. Washburn, "The Significance of the House," in Faith Bradford, *The Dolls' House* (Washington, D.C.: Smithsonian

Publication 4611, 1965).

82 Bradford to Brown, n.d., postmarked September 17, 1964, Object Documentation file, accession file 190558, Division of Political History, NMAH.

83 Ibid.

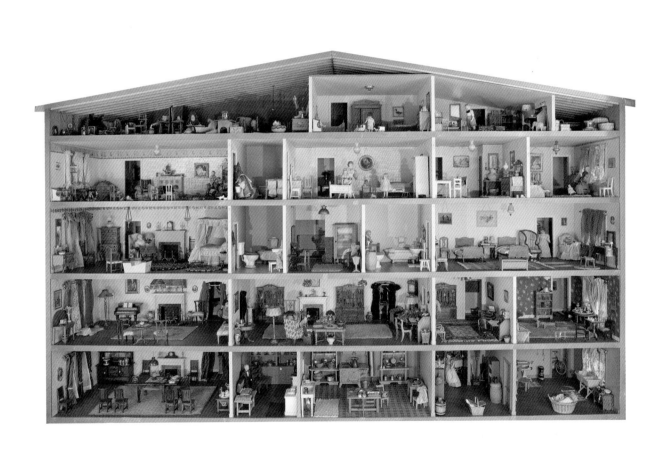

The Dolls' House:

Room by Room

Faith Bradford began her house tour on the ground floor in the Laundry, working right to left, then up one floor working left to right through successive rooms concluding with the Attic. The captions, below, are her descriptions as they appear on the model.

Laundry

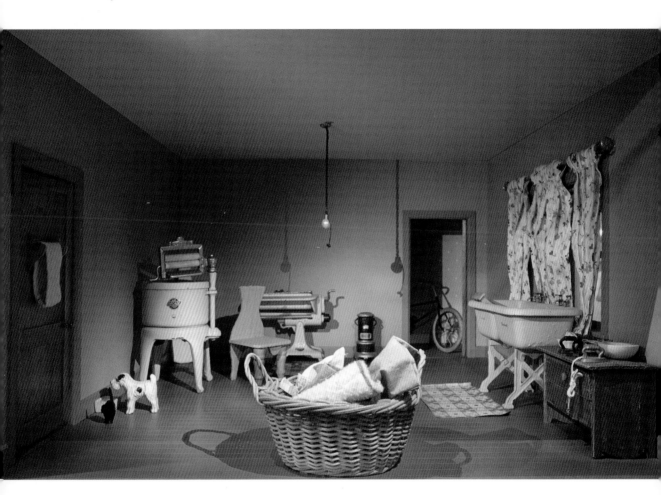

This room is equipped to handle the
laundry needs of a large family. The
hand-turned wringer, tubs, ironing
board, and irons are at the ready.

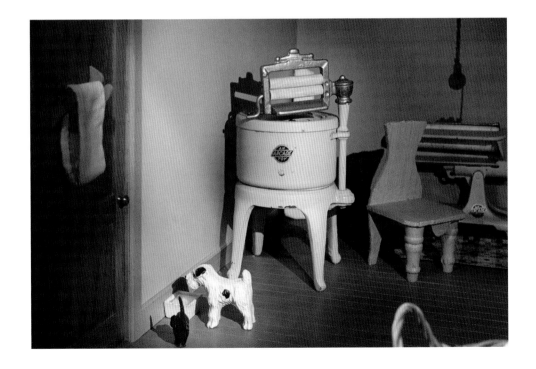

Pantry

This room contains shelves of
stores and food. Martha, the cook,
is examining food in the ice chest
refrigerator. An ice cream freezer
stands in the corner, and a new
"Hoover" amid the cleaning supplies.

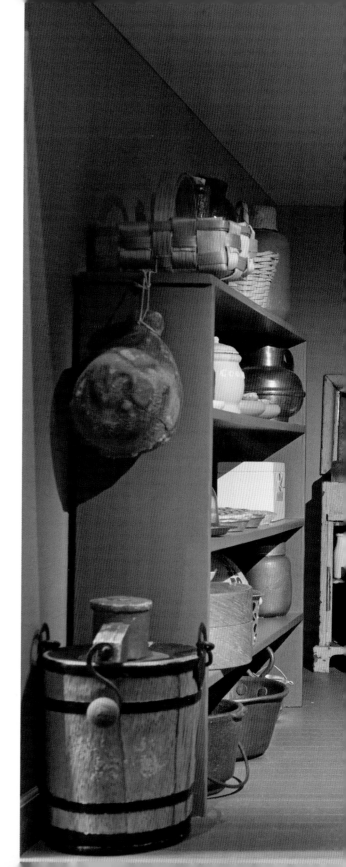

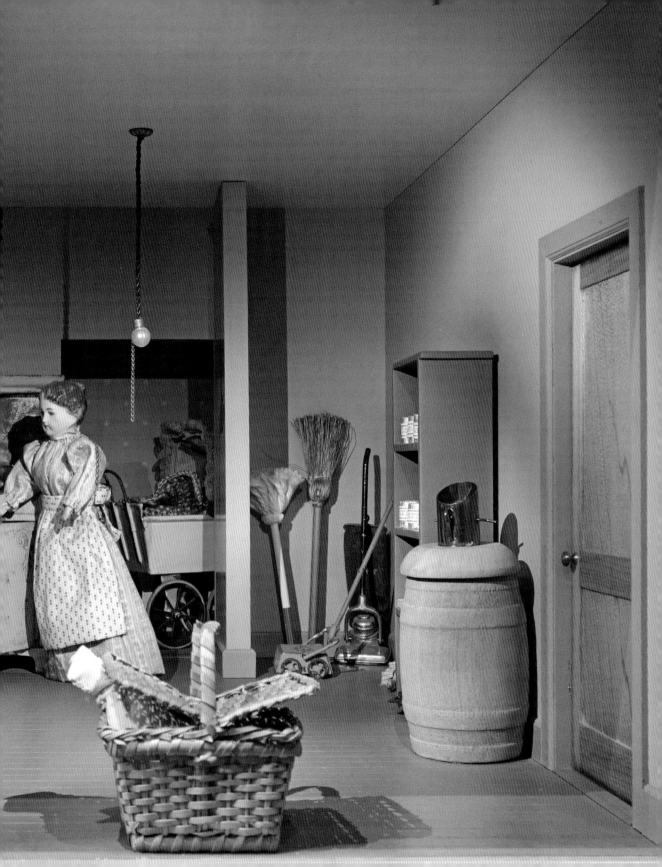

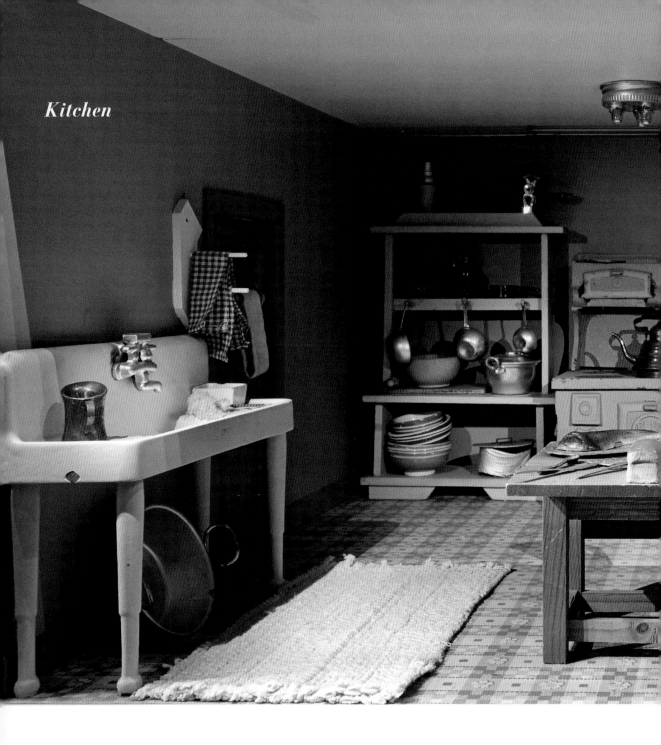

Kitchen

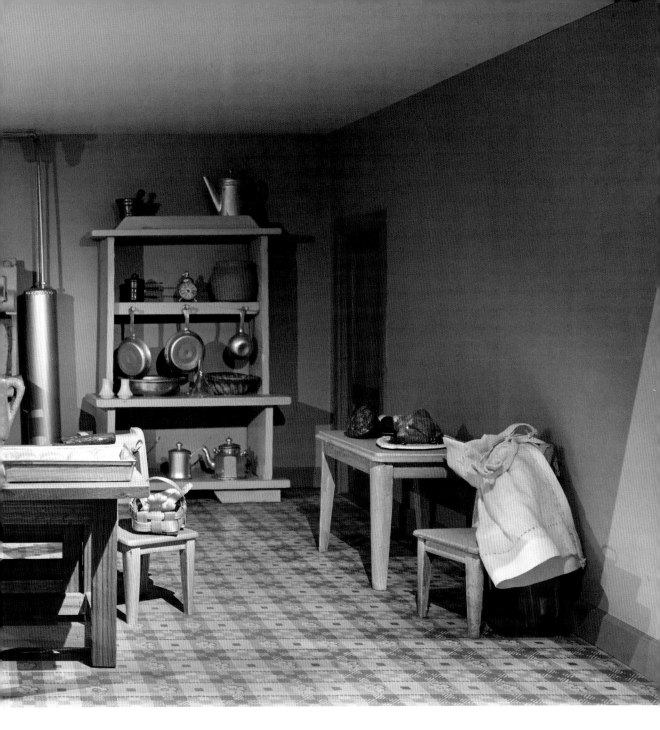

In a house of this period, the Kitchen is a large room. The stove is a coal-and-gas combination with the hot water bottle beside it. A set of 1900-style scales rests on top of the cabinet.

Butler's Pantry

This room is lined with cupboards and cabinets containing the family china, silver, and glass. It is evident from the dress of Gadsby, the butler, that evening is approaching.

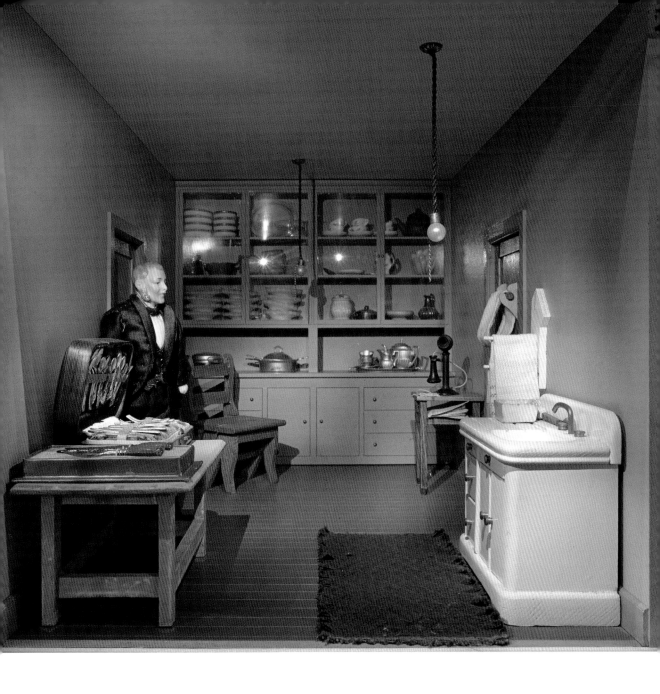

Dining Room

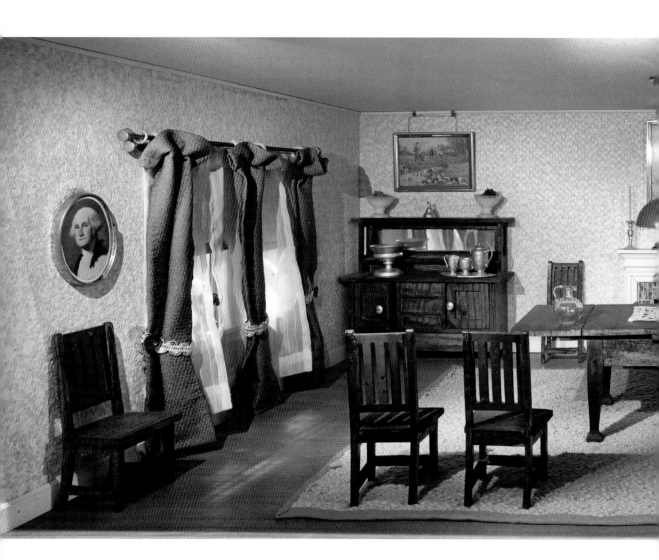

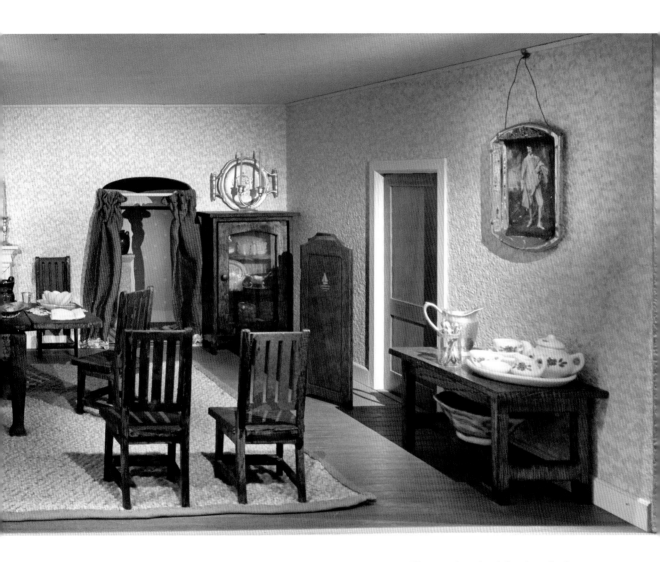

The weathered oak furniture in the
room was popular at the beginning
of the twentieth century. Cut glass
sparkles in the china cupboard and a
spoon holder rests on the table.

Drawing Room

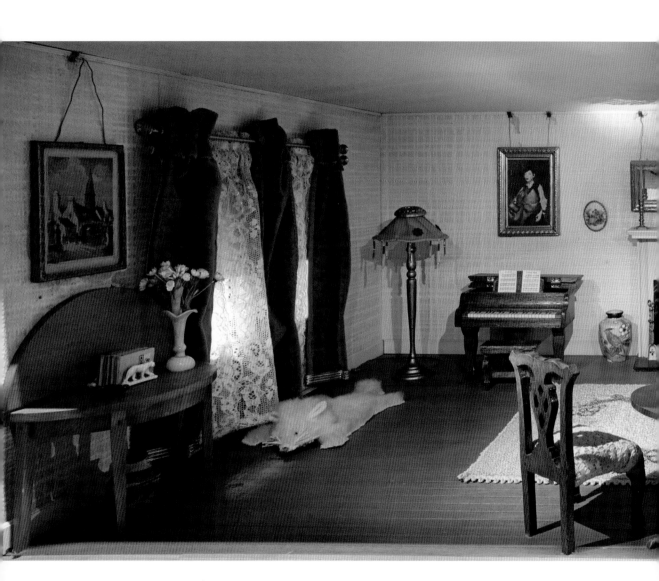

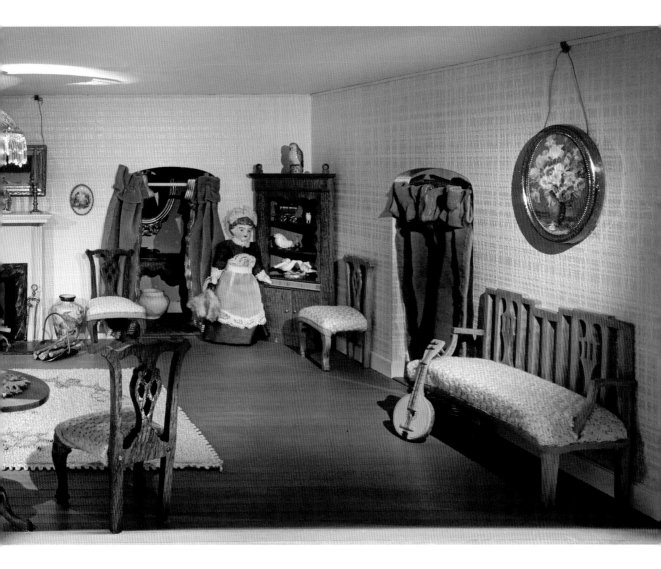

The mahogany furniture in this room has come down through several generations of the Doll family. Woodthrop, the parlor maid, is finishing her dusting for the day.

Library

This room contains more inherited
furniture, notably the breakfronts and
the Winthrop desk. It is a real library
with real books, comfortable chairs,
and a convenient reading light.

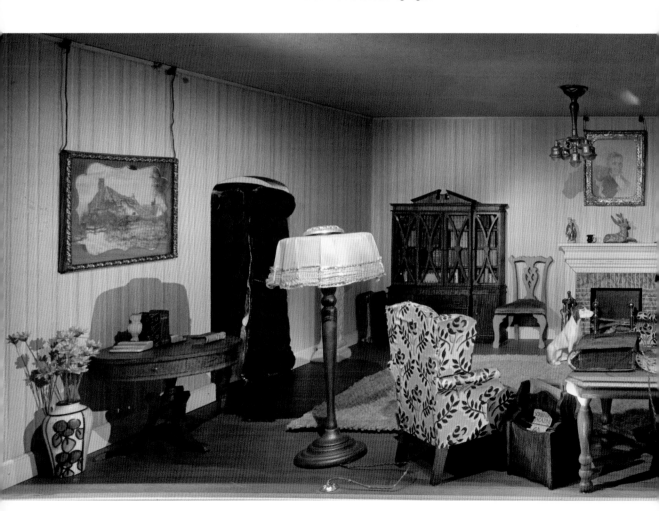

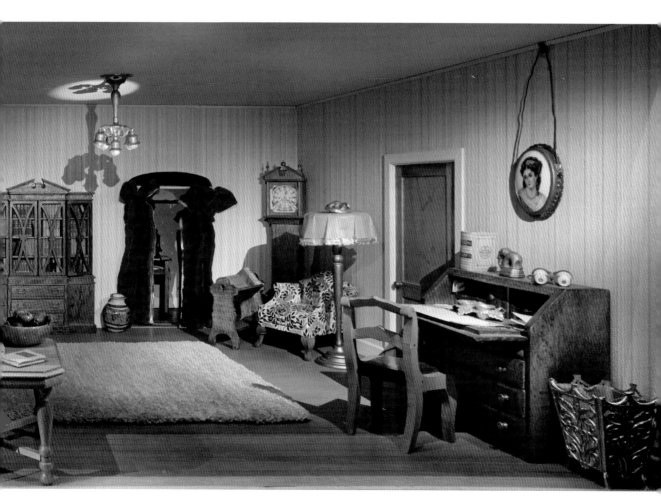

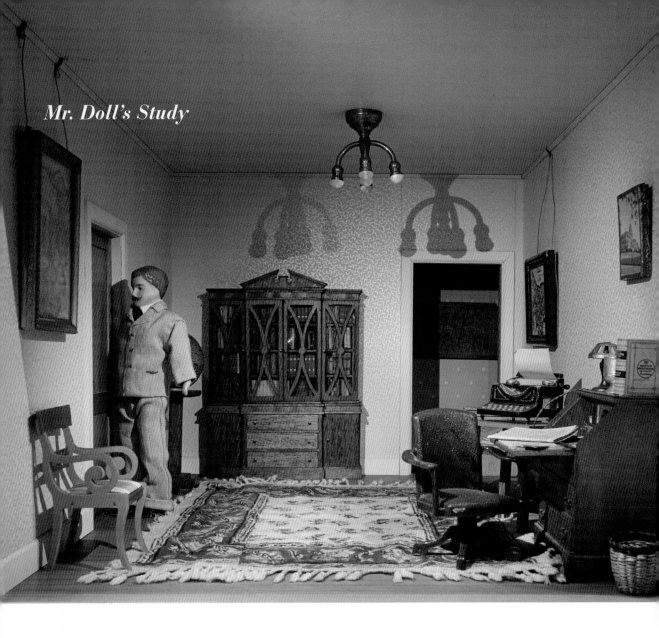

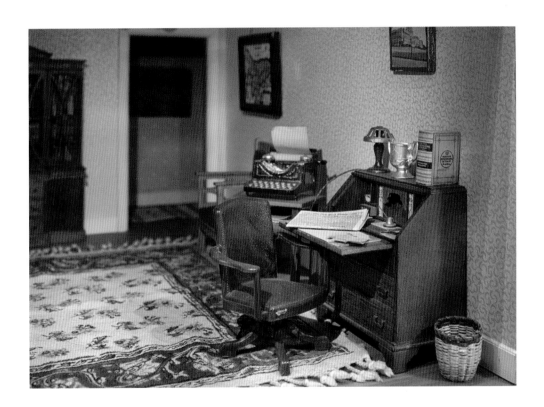

The Study, where we find Peter Doll,
is his special domain. His personal
books rest in the breakfront, and
on his desk is today's paper and a
typewriter ready for use.

Following page: The Parlor is used
for informal family gatherings. The
furnishings are reminiscent of the
Victorian style of interior decoration.

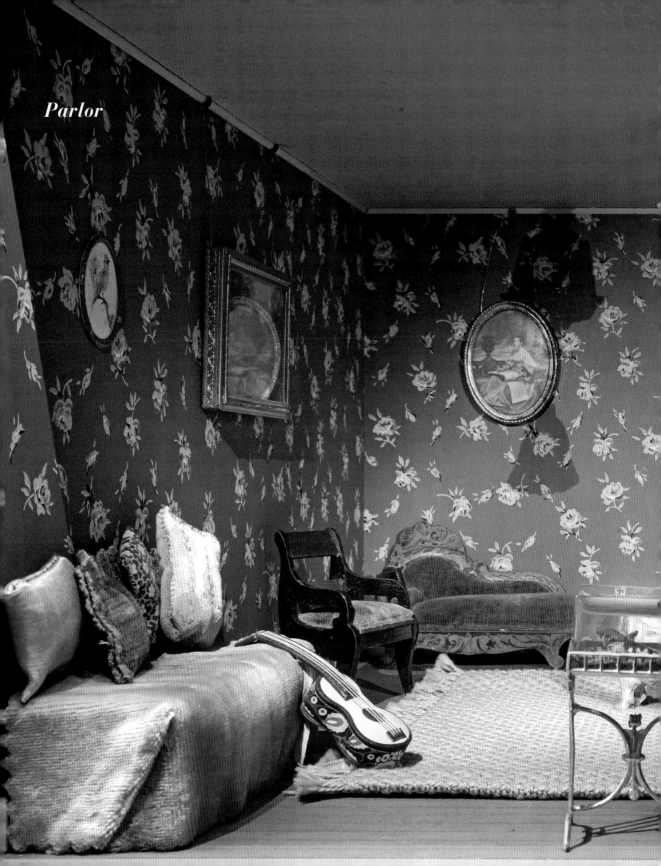

Parlor

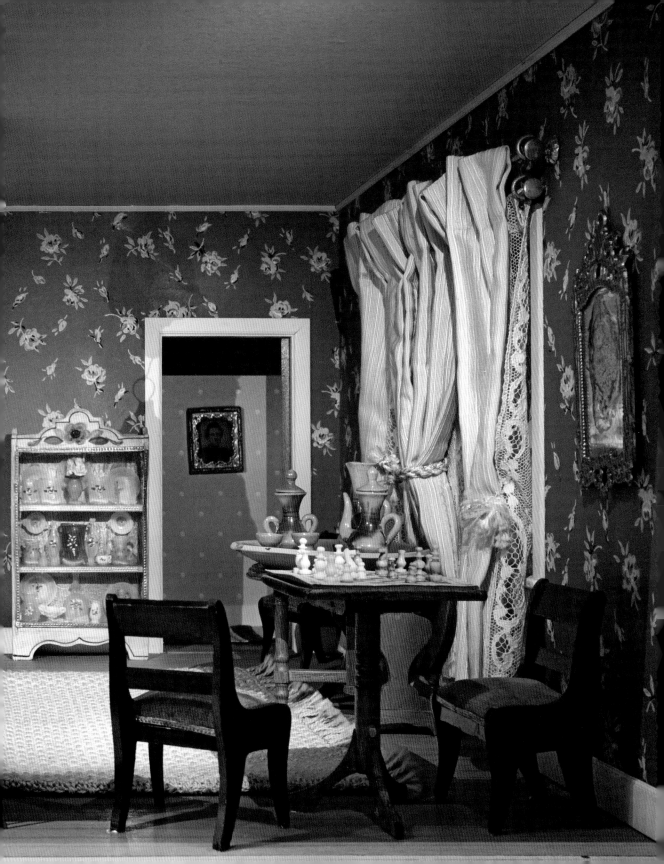

Parents' Bedroom

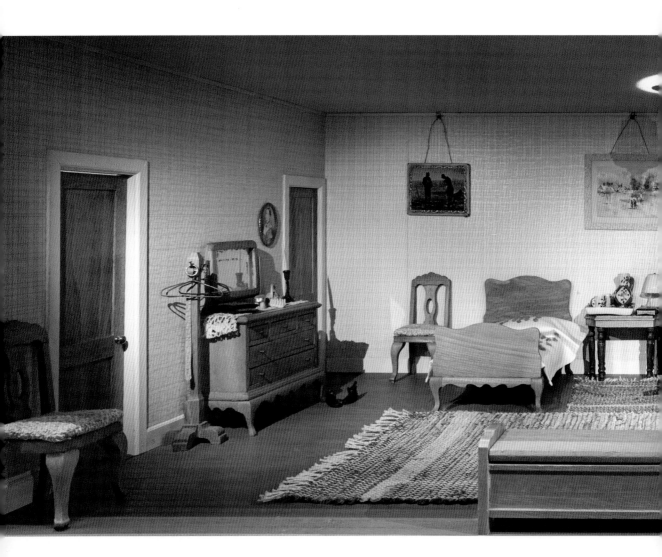

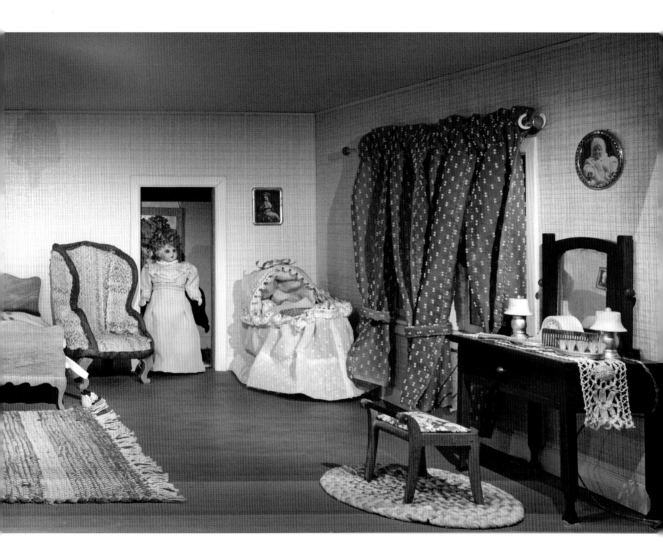

Rose Washington Doll may be seen at the door as she checks on the comfort and safety of her youngest children, Jimmy and Timmy, identical twins asleep in their bassinette.

Parents' Bathroom

Here we see one convenient feature
that the Guest Bathroom lacks—a
shaving stand.

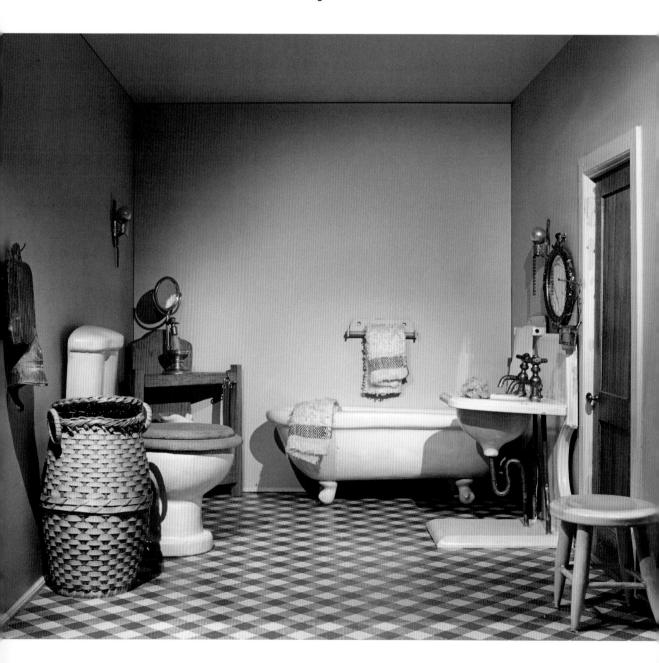

Sewing Room

In a family the size of the Dolls, a great amount of sewing is necessary. Mrs. Doll has a sewing woman in for a fortnight every spring and fall, and in between visits she takes care of making and mending.

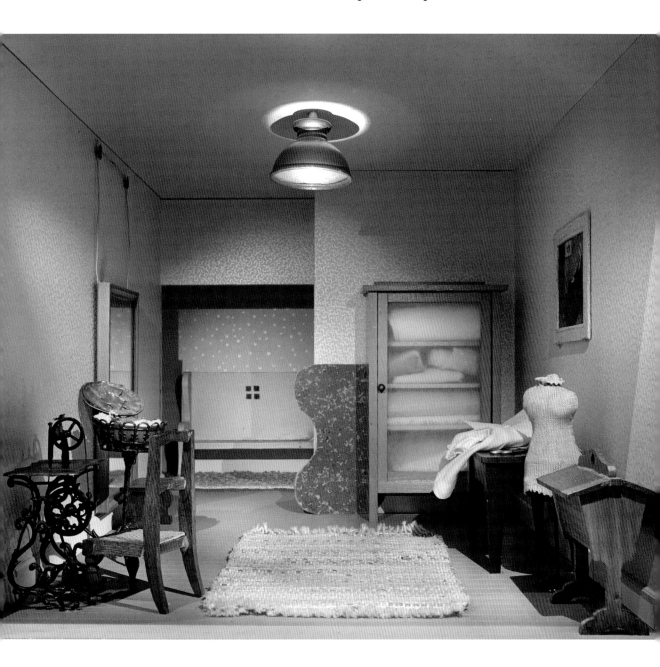

Guest Bathroom

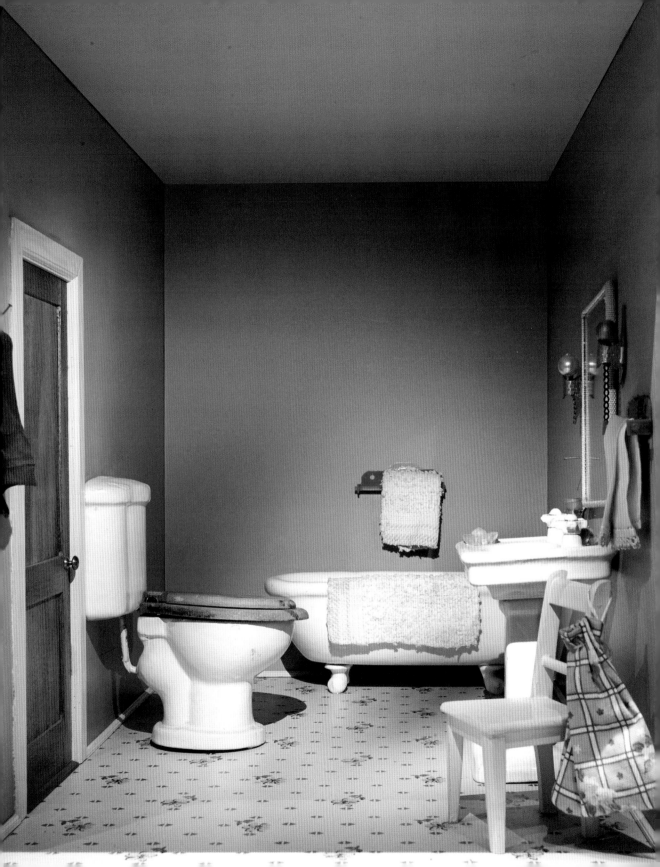

Guest Bedroom

The Guest Bedroom is temporarily occupied by Grandfather and Grandmother Doll. The room is furnished with beautiful inherited furniture dating from the Colonial Period.

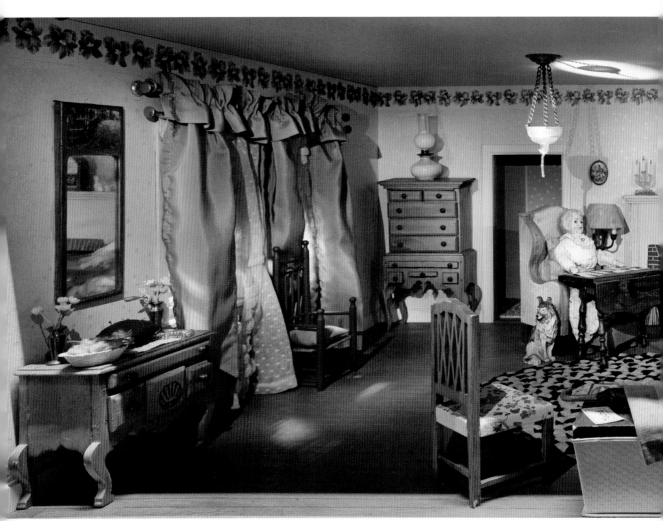

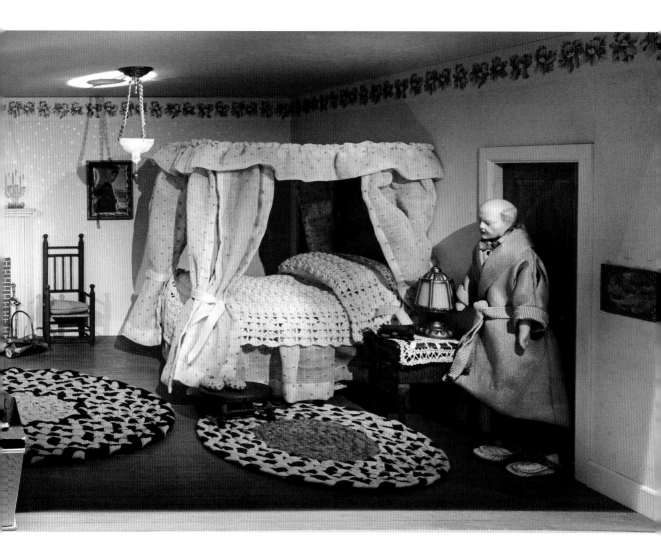

THIRD
FLOOR

Day Nursery

Christopher rides the rocking horse
while twins Lucy and Carol play with
dolls. The children's toys and books,
as well as implements for a tea party
or a bedtime snack, are kept here.

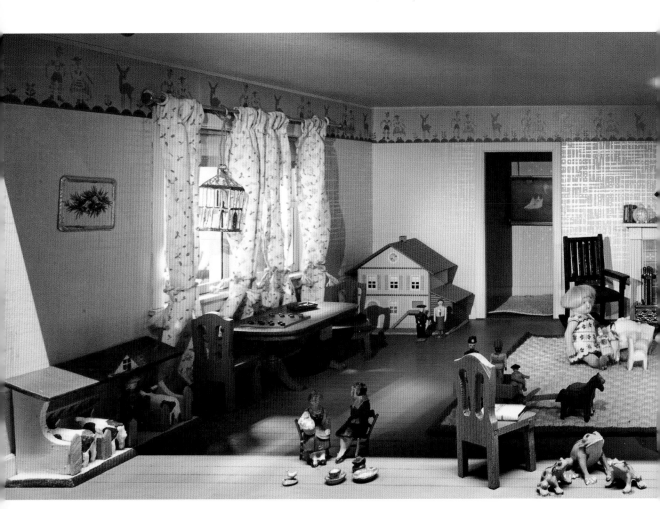

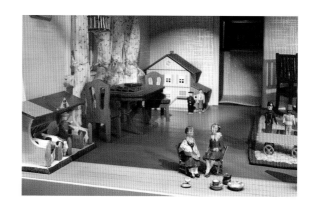

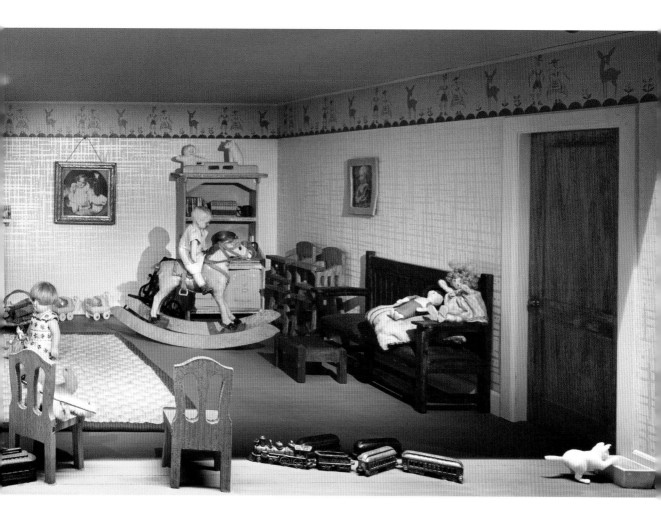

Children's Bathroom

With so many children to bathe, Mrs. Doll installed an old-fashioned "towel horse," excellent for holding many towels. Her work finished, chambermaid Christina Young is going downstairs.

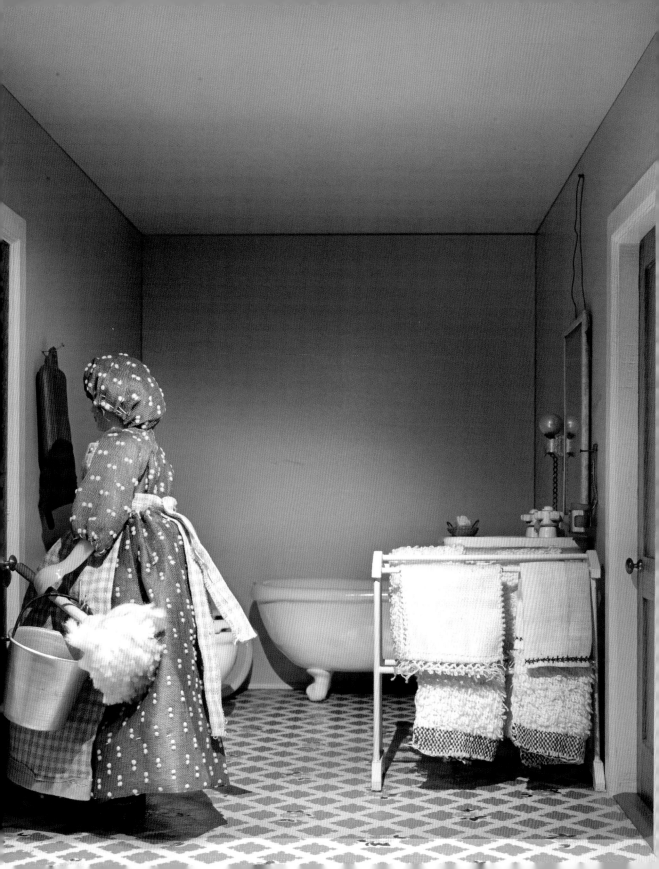

Night Nursery

Ann and David are admiring the cat, "Mrs. Peerie," while Nurse McNab waits to tuck David into his cradle. Lucy and Carol sleep together in the big bed, and Ann has her own little bed.

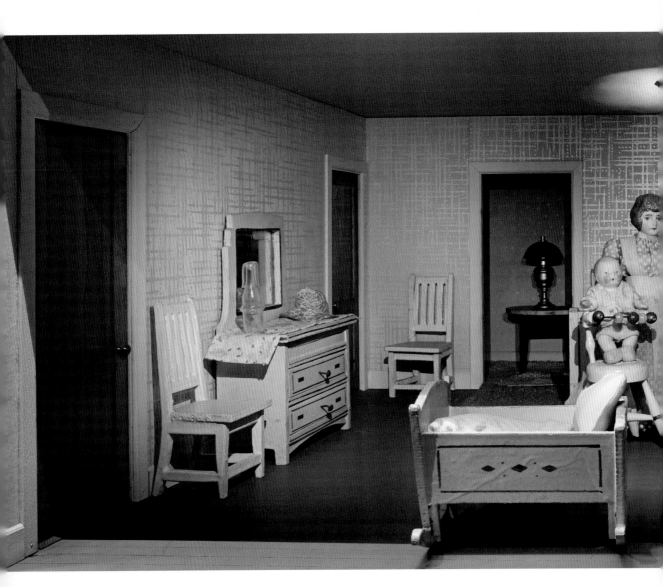

Following page: Golden oak furniture
in the Nurse's Room is typical of the
style and period of the house.

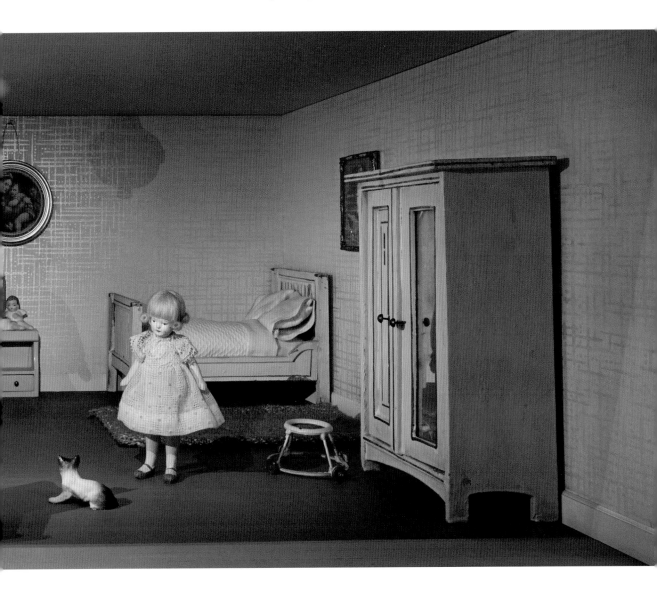

Nurse's Room

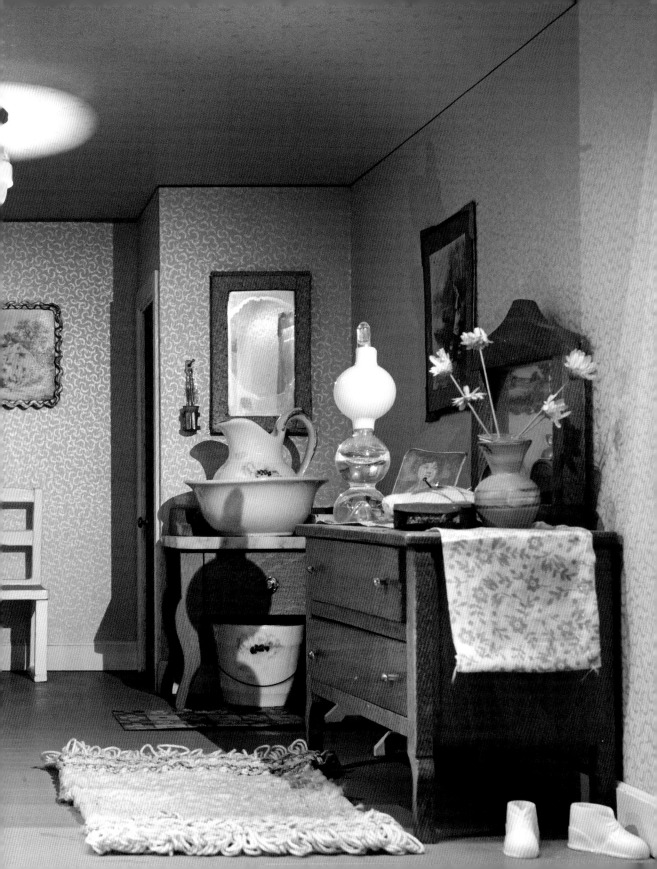

Now I lay me
down to sleep
I pray the Lord
my soul to keep
If I should die
before I wake
I pray the Lord
my soul to take
Amen

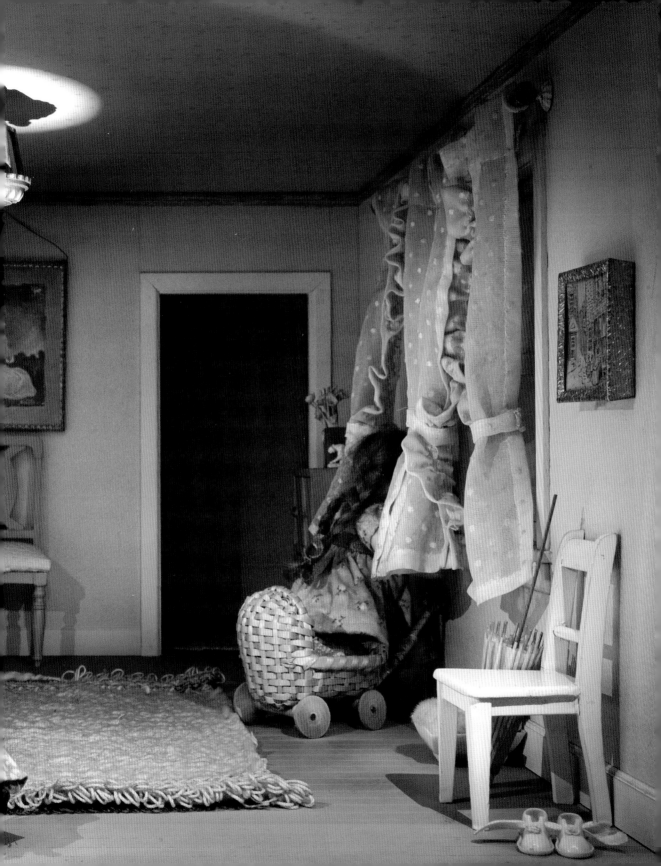

Trunk Room

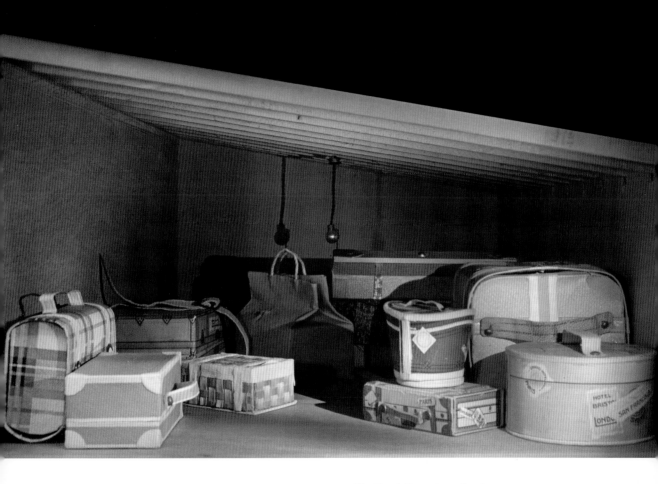

The Trunk Room is under the eaves
and is seldom visited except when a
trip is in prospect.

Previous page: A little girl's first room
of her own, this pink bedroom holds
a beautifully lettered child's prayer,
a cherished possession hanging over
Alice's bed.

Peter Jr.'s Room

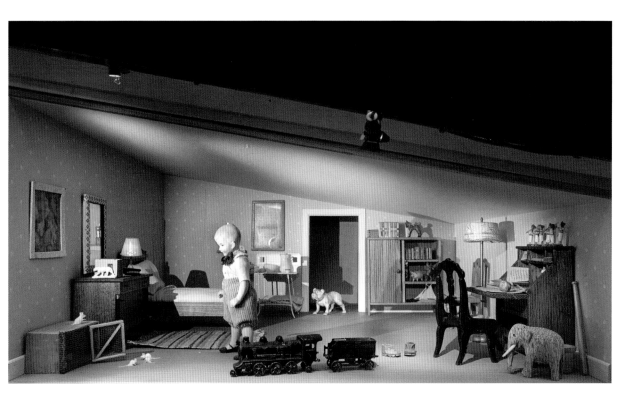

Peter, the eldest of the children, is
admiring his tame white rats. As
big brother, he is responsible for the
younger boys whose room is next to
his on the top floor.

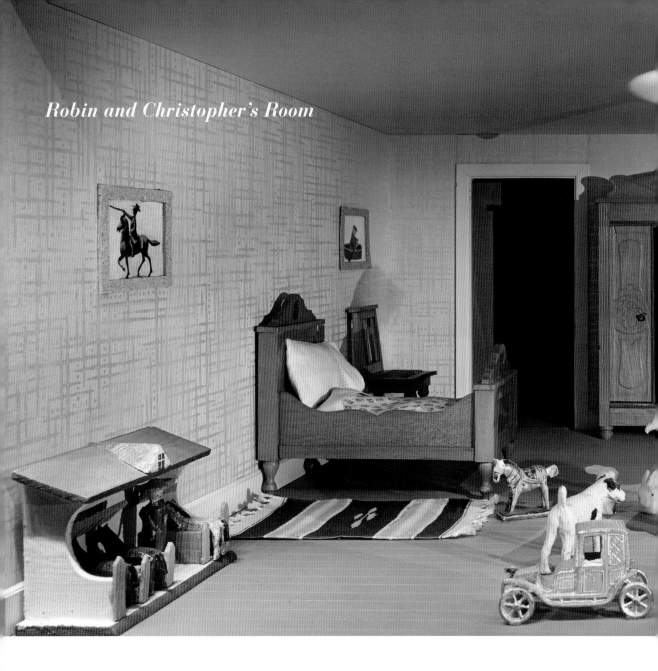

Robin and Christopher's Room

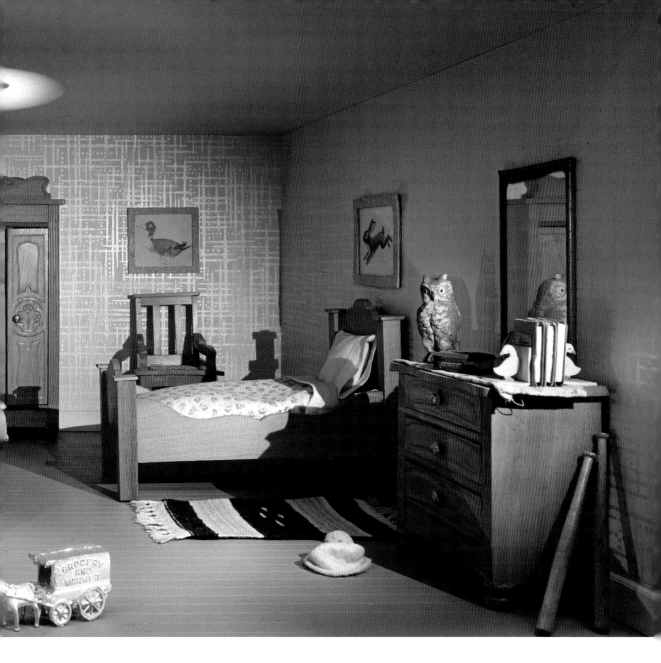

The golden oak furniture is of an earlier
generation. Robin is in the room with
his dog and pet rabbits that he will soon
take downstairs for the night.

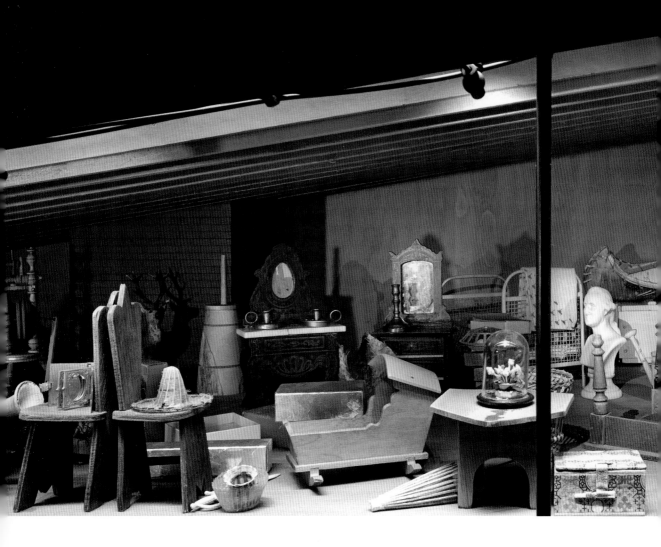

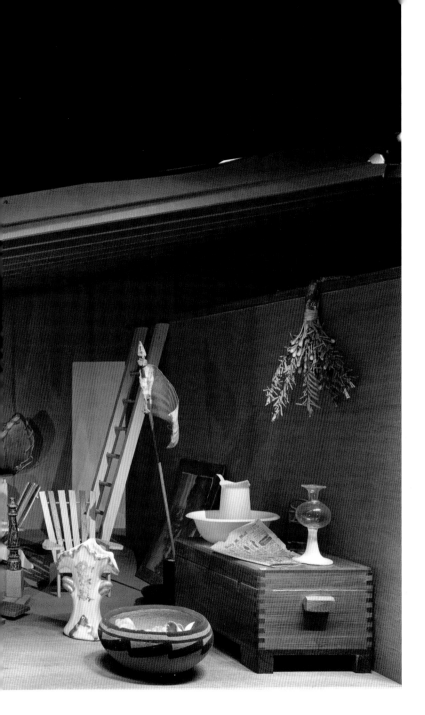

The Attic is filled with articles
temporarily out of use, pieces in need
of mending, inherited treasures, white
elephants, and household discards
still too dear to be thrown away.

The House and Home of
Peter Doll Jr.
and
his Family

Created ca
1956-1959

Faith Bradford

The Scrapbook:

Fabric Swatches of House Furnishings

Bradford's Modern House, 1959

1

The Story of a Doll House

ANOTHER DOLL HOUSE WAS CREATED (begun 1955 or 1956)

After the first Peter Doll's house proved so great an attraction in the U.S. National Museum, it seemed fitting that the house of the eldest son, Peter Doll Jr., a home of 1945-1955, should be created.

With the consent of the Museum authorities, the collection of the furnishings began in late 1955 or early 1956, and in 1958, a house that I designed was financed by the Smithsonian Institution and built by the Rogay firm of Model Makers who constructed the earlier house. The same general plan of a one-room deep house was followed so that all of the furnishings in every room could be plainly seen. As in the first house, the plan included a hallway across each floor, seen beyond open doors, giving a feeling of depth and reality and to avoid using space between the rooms for stairways.

The house was painted white with a faint suggestion of pattern perhaps to simulate a slightly rough concrete. The flat roof is painted black. Each floor has one coloring, the ground floor a light buff, the first floor a light grey, the second floor a slightly lighter grey.

The finished house was brought to my apartment December 17, 1958, and completely furnished by January 18, 1959 except for the addition of minor articles from time to time. I held the house until May 20, 1959 so that certain members of my family might see it since after it was set up and photographed in the Museum it was planned that it should be packed until it could be set up in the new Museum building, a matter of at least 5 years.

On May 15, 1959, Perry, from the Museum came to my apartment and put door knobs on the doors in Peter Doll Jr.'s house. He also fastened mirrors to the walls in the living room and in the bedrooms and the childrens' bathroom. On the 20th, men from the Museum came and took the house and the cartons that were filled with the furnishings. to the Museum. After lunch I went there and set up the furnishings all but two or three pieces that will be fastened to the walls before the house is photographed.

On May 21, 1959, I went to the Museum and put the finishing touches to the house of Peter Doll Jr., after which it was photographed. On May 25, 1959, I went to the Museum and began packing the house that is to be stored until it can be set up in the Museum building, not yet built.

Samples shown in connection with the descriptions of the rooms, are usually scraps of indicated materials rather then the finished article. There are a few exceptions such as the "His" and "Hers" towels.

Ground floor

Garage

Garage floor covering

Laundry

Laundry floor covering

Utility room

Bare floor

Lavatory

Floor covering

Lavatory, cont'd

No samples
 bath towels
 bath mat

hand towel

Shower curtain

115

Ground Floor, continued

Recreation room (1st section)

Floor covering

No sample available
of cushion covering,
white, with design of
pink rosebuds.

Dish towelling

Recreation room (2d section)

Floor covering same as in 1st section

Samples of coverings of
couch cushions.

Covering of cushion in rocking chair

Covering of cushion on
floor before couch

Covering of cushion of modern all-metal
stool (left of room, beyond archway)

Upholstery of couch

First Floor

Nursery

Floor covering

Rug in center of floor

Curtain material

Parents' bathroom

His *Hers*

Hand towels

Parents' bathroom

No sample available of floor
covering of oilcloth in tiny green
and white checks.

Shower curtain material

Plain green bath towel material
Same used for bath mat, and
wash cloths.

Parents' bedroom

No sample available of floor cov-
ering of dark green with wide white
stripe in border. It was a wash
cloth

Material of bed counter-
panes

First Floor, continued

Kitchen

Dining room

Floor covering

Rug

Table mat

Dish towel material

No available sample of
red and white checked
dish towel material

First Floor, continued

Living room

Floor covering

Window drapes

Couch upholstery

Venetian blinds

Cushion coverings

Upholstery of larger
chairs

Other chairs bought ready
upholstered

Second floor

Peter 3d's room

Rug

Counterpanes
and
Curtains

Children's bathroom

No sample available of the
floor oilcloth

Bathmat

Children's bathroom,cont'd

Bath towels

Hand towels

Wash cloths

Second floor, continued

Linda Lu's room

Rug

Counterpanes and pad on bed table, also
dressing table skirt

Headboards of beds

Linen room

Bare floor

All sheets and pillow cases
made from thin white cotton
material as above, usually cut
from handkerchiefs.

Linen room, cont'd

Crib blankets

Crib counterpanes

Hand towels
Some of the towels are
marked "His" and "Hers"
in red lettering.
See under, the bathrooms

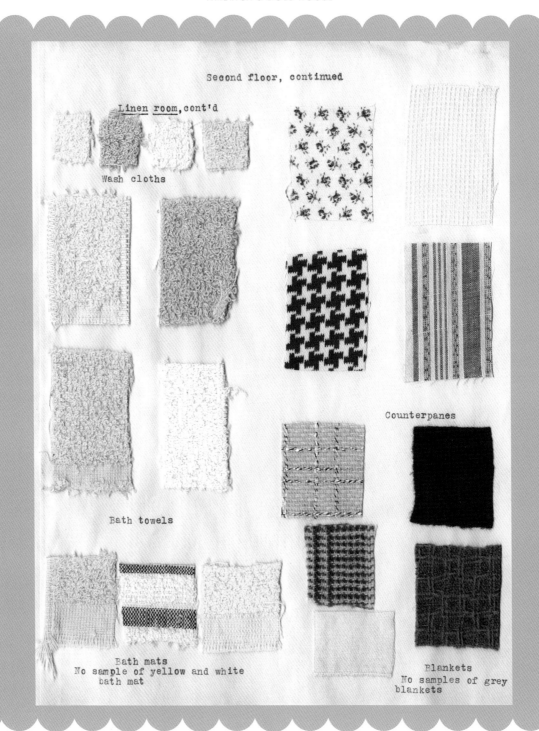

Second floor, continued

Linen room, cont'd

Wash cloths

Bath towels

Counterpanes

Bath mats
No sample of yellow and white
bath mat

Blankets
No samples of grey
blankets

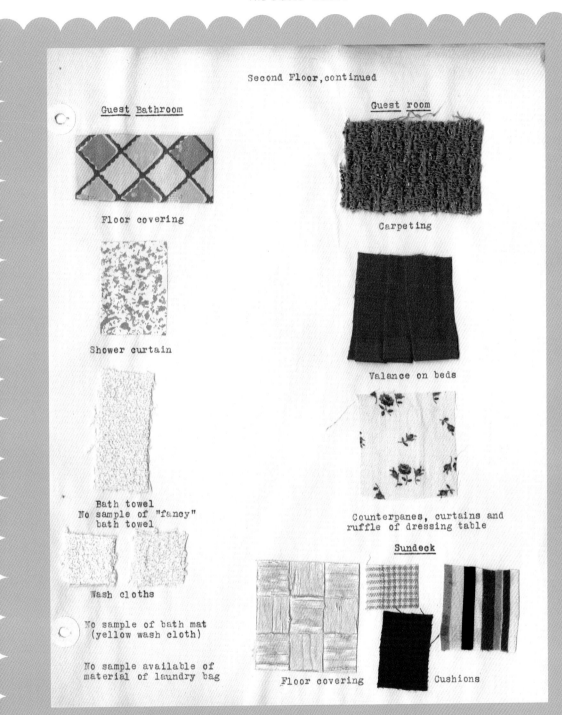

Second Floor, continued

Guest Bathroom

Floor covering

Shower curtain

Bath towel
No sample of "fancy"
bath towel

Wash cloths

No sample of bath mat
(yellow wash cloth)

No sample available of
material of laundry bag

Guest room

Carpeting

Valance on beds

Counterpanes, curtains and
ruffle of dressing table

Sundeck

Floor covering Cushions

123

Image Credits

P. 4
FAITH BRADFORD ABOUT 1896, COURTESY
OF PHILLIPS V. BRADFORD.

P. 10
MUSEUM VISITORS WITH BRADFORD'S
DOLLS' HOUSE, 1957, BRADFORD
SCRAPBOOK, DIVISION OF POLITICAL
HISTORY, NATIONAL MUSEUM OF
AMERICAN HISTORY (HEREAFTER NMAH),
SI #45204.

P. 13
DOLLS' HOUSE SHOWN AT GADSBY'S
TAVERN, BRADFORD SCRAPBOOK, NMAH.

P. 12
DOLLS' HOUSE EXHIBITED ON THE FLOOR
OF THE ARTS & INDUSTRIES BUILDING, 1963,
NMAH, SI #48669.

P. 14
RUG FROM MODEL, 1933, BRADFORD
SCRAPBOOK, NMAH.

P. 15
SELECTION OF CHRISTMAS CARDS, 1951–52,
SMALL DOCUMENTS FILE, NMAH, PHOTO BY
HUGH TALMAN, SI #ET2009-25094.

P. 17
MODERN HOUSE, 1959, BRADFORD
SCRAPBOOK, NMAH, SI #45632.

P. 19 (TOP)
POSTCARD, ARTS & INDUSTRIES BUILDING,
N.D., BRADFORD SCRAPBOOK, NMAH.

P. 19 (BOTTOM)
ARTS & INDUSTRIES BUILDING, 1948, NMAH,
SI #99-2202.

P. 21
FRANK A. TAYLOR (LEFT) AND MODEL, 1923,
DIVISION OF WORK AND INDUSTRY, NMAH,
SI #30776 AND #11174.

P. 22 (TOP)
MODERN ARCHITECTURAL RENDERING, FIRST
LADIES HALL, NMAH

P. 22 (BOTTOM)
BEAUX ARTS ARCHITECTURAL RENDERING,
FIRST LADIES HALL, NMAH.

P. 23
FIRST LADIES HALL, 1955, NMAH, SI #44606.

P. 25 (LEFT)
MRS. JULIAN-JAMES (LEFT) AND MRS. HOES,
1923, NMAH, SI #56-983.

P. 25 (RIGHT)
JOHN BULL LOCOMOTIVE, 1944. DIVISION
OF WORK AND INDUSTRY, NMAH,
SI #36832.

P. 27
FAITH BRADFORD ABOUT 1900, COURTESY
OF PHILLIPS V. BRADFORD.

P. 27
GEORGE WINCHESTER STONE'S HOUSE,
CHEVY CHASE, MD., 1923, COURTESY OF
CHEVY CHASE HISTORICAL SOCIETY.

P. 28
BRADFORD'S MINIATURE FURNISHING
COLLECTION AT HER CHEVY CHASE, MD.
HOME, 1930, BRADFORD SCRAPBOOK,
NMAH.

P. 31
BRADFORD'S DOLL HOUSE MODEL AS
EXHIBITED AT WOODWARD & LOTHROP,
1933, BRADFORD SCRAPBOOK, NMAH.

P. 33
CURATOR MARGARET BROWN WITH FIRST
LADIES HALL MODEL, 1955, NMAH,
SI #72-4931.

P. 35
ROBERT GEOGHEGAN WITH EAST FRONT
CAPITOL MODEL, 1951, BRADFORD
SCRAPBOOK, NMAH.

P. 37
GOLDFISH AQUARIUM, PARLOR, THE DOLLS'
HOUSE, NMAH, PHOTO BY HUGH TALMAN,
SI #ET2009-25111.

P. 39
TYPESCRIPT LABEL DRAFT, 1951, OBJECT
DOCUMENTATION FILE, NMAH.

P. 42 (TOP)
BRADFORD WITH VISITOR, 1966, COURTESY
OF THE WASHINGTON EVENING STAR.

P. 42 (BOTTOM)
LAUNDRY WITH PARTIAL VIEW OF BIKE,
NMAH, PHOTO BY HUGH TALMAN,
SI #ET2009-25106.

P. 45
CARMICHAEL, QUEEN MOTHER,
EISENHOWER, AND BROWN, 1954, NMAH,
SI #43262-C.

P. 51
DETAIL, LEFT SECTION, MODERN HOUSE,
1959, BRADFORD SCRAPBOOK, NMAH,
SI #45931A.

P. 52–3
DETAIL, RIGHT SECTION, MODERN HOUSE,
1959, BRADFORD SCRAPBOOK, NMAH,
SI #45632C.

P. 55
ROCKET ROW, ARTS & INDUSTRIES BUILDING,
1965, SIA.

P. 56–7
MINIATURES COLLECTED AFTER 1959, NMAH,
PHOTO BY HUGH TALMAN, SI #ET2009-25093.

P. 59 (LEFT)
MALL ENTRANCE SHOWING THE
WASHINGTON MONUMENT, 1964, SIA,
SI #2008-4962.

P. 59 (RIGHT)
PARKING ENTRANCE, MUSEUM OF HISTORY &
TECHNOLOGY, 1964, SIA, SI #2008-4963.

P. 62
MINIATURE LAMP, THE DOLLS' HOUSE.
BRADFORD SCRAPBOOK, NMAH, PHOTO
BY HUGH TALMAN, SI #ET2009-25119.

P. 68
THE DOLLS' HOUSE, NMAH, PHOTO BY
HAROLD DORWIN AND HUGH TALMAN,
SI #ET2008-12599.

P. 70–1
LAUNDRY, NMAH, PHOTOS BY HUGH TALMAN,
SI #ET2009-25099.

P. 72–3
PANTRY, NMAH, PHOTO BY HUGH TALMAN,
SI #ET2009-25227.

P. 74–5
KITCHEN, NMAH, PHOTO BY HUGH TALMAN,
SI #ET2009-25228.

P. 77
BUTLER'S PANTRY, NMAH, PHOTO BY
HUGH TALMAN, SI #ET2009-25098.

P. 78–9
DINING ROOM, NMAH, PHOTO BY
HUGH TALMAN, SI #ET2009-25271.

P. 80–1
DRAWING ROOM, NMAH, PHOTO BY
HUGH TALMAN, SI #ET2009-25264.

P. 82–3
LIBRARY, NMAH, PHOTO BY HUGH TALMAN,
SI #ET2009-25235.

P. 84–5
MR. DOLL'S STUDY. NMAH, PHOTOS BY
HUGH TALMAN, SI #ET2009-25222.

P. 86–7
PARLOR, NMAH, PHOTO BY HUGH TALMAN,
SI #ET2009-25221.

P. 88–9
MR. AND MRS. DOLL'S BEDROOM, NMAH,
PHOTO BY HUGH TALMAN, SI #ET2009-25218.

P. 90
PARENT'S BATHROOM, NMAH, PHOTO
BY HUGH TALMAN, SI #ET2009-25241.

P. 91
SEWING ROOM, NMAH, PHOTO BY
HUGH TALMAN, SI #ET2009-25242.

P. 93
GUEST BATHROOM, NMAH, PHOTO BY
HUGH TALMAN, SI #ET2009-25247.

P. 94–5
GUEST BEDROOM, NMAH, PHOTO BY
HUGH TALMAN, SI #ET2009-25260.

P. 96–7
DAY NURSERY, NMAH, PHOTO BY
HUGH TALMAN, SI #ET2009-25257.

P. 99
CHILDREN'S BATHROOM, NMAH, PHOTO
BY HUGH TALMAN, SI #ET2009-25248.

P. 100–1
NIGHT NURSERY, NMAH, PHOTO BY
HUGH TALMAN, SI #ET2009-25253.

P. 102–3
NURSE'S ROOM, NMAH, PHOTO BY
HUGH TALMAN, SI #ET2009-25211.

P. 104–5
ALICE'S ROOM. NMAH, PHOTO BY
HUGH TALMAN, SI #ET2009-25209-2.

P. 106
TRUNK ROOM, NMAH, PHOTO BY
HUGH TALMAN, SI #ET2009-25204.

P. 107
PETER JR.'S ROOM, NMAH, PHOTO BY
HUGH TALMAN, SI #ET2009-25215-2.

P. 108–9
ROBIN AND CHRISTOPHER'S ROOM, NMAH,
PHOTO BY HUGH TALMAN, SI #ET2009-25254.

P. 110–11
ATTIC, NMAH, PHOTO BY HUGH TALMAN,
SI #ET2009-25279 AND -25280

P. 112–123
FABRIC SWATCHES, THE MODERN HOUSE,
1959. BRADFORD SCRAPBOOK, NMAH.

I wish to acknowledge the many people who informed and enlivened this book. I am especially indebted to Phillips V. Bradford, who kindly made available family photographs, letters, and reminiscences. Many more individuals shared memories about Bradford's family and Chevy Chase, Maryland neighborhood, including Jean Sperling, Libby Meid, John Meid, Jim Thurman, Andrew Cummings, and Ephraim Jacobs. Evelyn Gerson and Emily Nissley of the Chevy Chase Historical Society provided photographs of Bradford's home. Eric Nystrom generously allowed me to cite his work on the history of exhibit making at the museum, and called my attention to a photograph of Frank A. Taylor. I wish to thank Emily Ross Taylor, Herbert R. Collins, Keith E. Melder, Barbara J. Coffee, and Benjamin W. Lawless for sharing their memories of Bradford and her models. I also had the benefit of extended reminiscences about the museum's exhibits and personalities with Ann Golovin, Dana Little, Tom Haynes, and Francis Klapthor Andrews.

I wish to thank my friends and colleagues whose consideration and encouragement helped make this book possible, including Harry R. Rubenstein, Barbara Clark Smith, Harry Rand, Lisa Kathleen Graddy, Sara Murphy, Marilyn Higgins, Debra Hashim, Patricia Mansfield, Jim Gardner, David Allison, Kate Henderson, Lynne Gilliland, Beth Richwine, Lauren Telchin-Katz, Nigel Briggs, Marcia Powell, the late Constantine Raitzky, Mary Miller, Catherine Perge, Tom Bower, Nan Card, Raelene Worthington, Karen Garlick, Steve Hemlin, Keith Boi, Helena Wright, William Yeingst, Peter Liebhold, William Withuhn, Susan Tolbert, Ellen Alers, Amy Ballard, Cynthia Field, Melinda Machado, and Brent D. Glass.

New digital images of the Dolls' House and high-resolution scans of archival negatives of the Modern House are the distinct contribution of Smithsonian photographers Hugh Talman, Harold Dorwin, and John Dillaber.

For kind advice and constructive criticism I wish to thank Rosemary Regan, who edited and commented upon a first draft of the manuscript, and my readers Miriam Formanek-Brunell, Beverly Gordon, Marcel C. LaFollette, Pamela M. Henson, and Robert C. Post.

At Princeton Architectural Press I am indebted to editors Jennifer Thompson and Carolyn Deuschle.

WLB